IMAGES
of America

DELHI
CINCINNATI'S WESTSIDE

On the cover: The Sisters of Charity encouraged the betterment of the mind, spirit, and body. In this image, a group of young female students from Mount St. Joseph Academy, called minims, exercise in a playhouse on school property in the early decades of the 20th century. Many community activities for children sprung up in the 1930s, including Boy Scout troops and the Knothole movement, which organized competitive baseball and softball games for boys and girls. Harry Dinkelaker was in charge of most of these events and could often be seen watching a game and cheering on his team.

DELHI
CINCINNATI'S WESTSIDE

Christine Mersch

ARCADIA

Copyright © 2005 by Christine Mersch
ISBN 0-7385-3440-4

Published by Arcadia Publishing
Charleston SC, Chicago IL, Portsmouth NH, San Francisco CA

Printed in Great Britain

Library of Congress Catalog Card Number: 2005925973

For all general information contact Arcadia Publishing at:
Telephone 843-853-2070
Fax 843-853-0044
E-mail sales@arcadiapublishing.com
For customer service and orders:
Toll-Free 1-888-313-2665

Visit us on the Internet at http://www.arcadiapublishing.com

CONTENTS

Acknowledgments — 6

Introduction — 7

1. Daily Jobs — 9

2. Green Thumbs — 27

3. Spirituality and Schools — 47

4. Places to See — 79

5. Great Events — 91

6. Delhi Neighbors — 103

ACKNOWLEDGMENTS

First and foremost, I would like to thank the members of the Delhi Historical Society, especially Peg Schmidt, for so generously allowing me to access their photographs and to continually pick their brains for information. A huge thanks also goes to the Sisters of Charity, specifically Sr. Judith Metz and Sr. Pat McQuinn. These two women offered plenty of resources and encouragement. Thank you to the local Delhi residents, specifically Dan Elsaesser at The Farm and Carolyn and Dick Witterstaetter, who gave their time and photographs to help me tell this story. And thank you to all the Delhi residents of yesterday, today, and tomorrow for making this township such a wonderful environment.

I would also like to give a sincere thanks to Kate Schuermann for being the impetus in this book's creation and to Mark Den Herder for giving me constant support to continue. Also, my thanks to Kevin Grace at the University of Cincinnati's Archive and Rare Books Department for being my mentor on this book. And finally, thank you to my parents, Betty and Lou, for being mentors in my life.

INTRODUCTION

Those in Cincinnati playfully speak about the division between Eastsiders and Westsiders. It is commonly said that those who are born on the west side stay on the west side. This popular saying definitely holds true in Delhi, a suburb of Cincinnati where family roots hold strong, even today.

The lure of Delhi started in May 1789, when John Cleves Symmes instructed his brother, Timothy Symmes, to build a village at South Bend, the present-day Delhi. Fights between the Native Americans and early settlers led to the creation of the Treaty of Greenville in 1795, in which the Native Americans surrendered much of southern Ohio to the U.S. government. The original boundaries of South Bend included what are now parts of Cincinnati, Miami Township, and all of Delhi and Green Townships.

In 1817, Delhi Township was incorporated. The area was originally named "Del High," and there are varying theories as to why that name was chosen. Some people speculate that the name comes from New Delhi in India because both communities have similar topography. Others believe the Grecian city of Delphi had some influence over the title. Only the people involved in making the initial decision know the true answer.

What we do know is that many families have migrated to and propagated in this area over the years. Many families who settled the area remain here today, including the Runck, Williams, Lipps, Murphy, Witterstaetter, and Martini families. Family businesses that sprung up in the early 19th century continue to thrive today through the work of descendants. The following chapters discuss the well-established families in the area and the places that they worked, worshipped, and lived.

Chapter one, entitled "Daily Jobs," highlights the work that residents did day in and day out. Workers who appear in these image include milkmen, blacksmiths, mechanics, and barbers, as well as those who served the public as members of the fire and police departments.

The soil composition in the area was well suited to growing fruits and vegetables. Many settlers in Delhi considered themselves gardeners instead of farmers. Since Delhi's expansive lands were perfect for growing flowers, it did not take long for a variety of greenhouses to start dotting the land. This led to the creation of a common saying: "Delhi has more acres of land under glass than any other area." Because the local florists have been and still are important to the economic growth of this area, they have warranted their own chapter in this book, appropriately titled "Green Thumbs."

In chapter three, "Spirituality and Schools," readers will get a glimpse of Delhi's thriving religious and educational communities. Schools were often built as additions to churches or parishes, or vice versa. In Delhi, one is likely to find a church on every corner. While this book cannot show all the corners, it will show the main ones that have had a lasting effect on local residents. Delhi also has its fair share of public schools, which are also prominently highlighted in this chapter.

Sites that are not part of a parish or school are included in chapter four, "Places to See." These landmarks include the Delhi branch of the Cincinnati and Hamilton County public library, the Delhi Historical Society—two places where most of the information in this book was found—and the Anderson Ferry, a viable mode of transportation even today. Pictures of extracurricular activities, such as sports or horse shows, can be found in chapter five, entitled "Great Events." This chapter highlights typical activities that residents spent their time on when they were not working.

Finally, in chapter six, "Delhi Neighbors," readers can take a glimpse into the past to see familiar names come alive. This collection of photographs focuses on the people who have left their marks on this Westside community and whose footsteps we walk in today.

I have attempted to showcase images of people and places that are familiar as well as those that have almost slipped from memory. In studying Delhi history, I have learned much more in-depth information about the names and places I have heard legendary stories about. Now I drive on the streets of my township and understand the history behind the street signs and buildings I pass. I hope to leave you with some of this knowledge as you read through the book. Enjoy.

—Christine Mersch

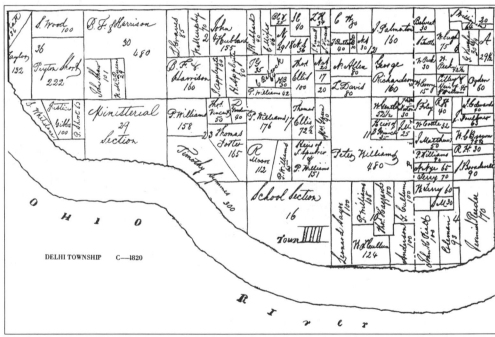

This map shows the Delhi area around 1920. The population of Delhi in 1860 was 2,700, and by 1880 it had nearly doubled, reaching 4,738. In 2005, the population is approximately 31,059. Some of the early pioneers in the Delhi area include Henry and Margaret Darby, Susan and Joseph Mayhew, and Peter and Ann Williams.

One
DAILY JOBS

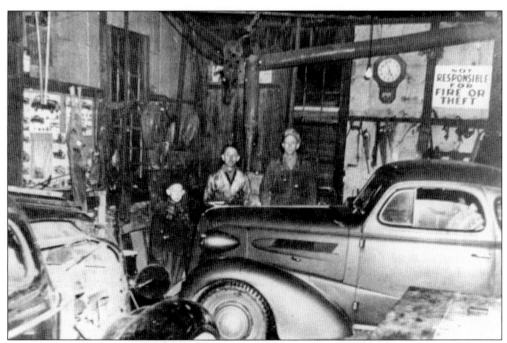

John P. Backscheider owned and operated the Backscheider Blacksmith Shop around 1860. John and his wife, Mary Menninger, built a home near the shop on Mayhew Road and had two daughters, Frances and Amelia. John died in 1890, and Charles Backscheider, believed to be John's brother, assumed control of the shop. This photograph shows the shop in the early 1940s. Although there are cars in the foreground, there are still horseshoes hanging from the rafters.

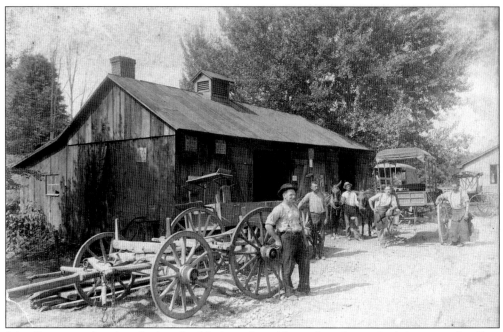

John Bens owned and worked at this blacksmith and horseshoe shop, which he opened at Five Points on Rapid Run Pike around 1900. Previously, John had worked as an apprentice at the Fischesser Horseshoeing and Wagon Shop. Bens's Blacksmithing Shop was one of the last of Delhi's five blacksmiths, staying open until John Bens's death in 1940 at 80 years of age.

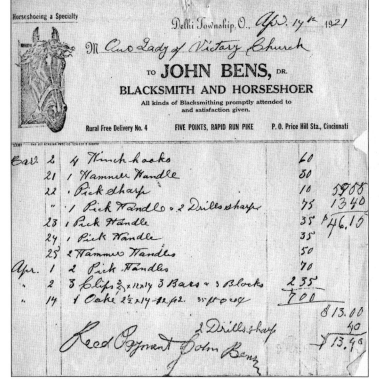

This paper lists the services and payments rendered at John Bens's blacksmith shop on April 14, 1921. John was one of 12 children of Ignatz and Angelica Bens. Ignatz Benz was born in Germany on January 31, 1817. He married Angelica Jonas, and the two immigrated to the United States, eventually settling on Lower River Road. Ignatz worked as manager of Wocher's Place, a winery. At some point, he changed the spelling of his last name from Benz to Bens. In 1855, the Bens family moved to a farm on the south end of Need Road.

Samuel Fischesser opened the Fischesser blacksmith shop in 1895 on the corner of Neeb and Cleves Warsaw Roads. Samuel's son, John Fischesser, was born in Ohio in 1879 to Frances and Sothenes Fischesser. John may have inherited the knack for blacksmithing from his father, who worked as a blacksmith in Price Hill. John and his wife, Katie, made their home on farmland that was passed down to them from her father, Henry Schwartz, after he died in 1915.

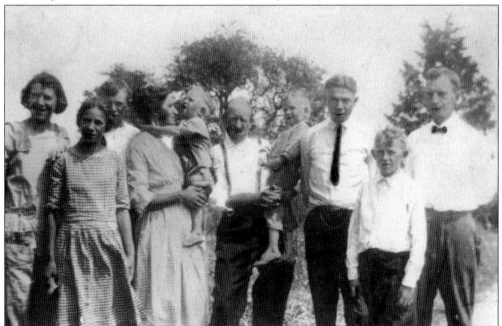

In this 1925 photograph of the Fischesser family, John is standing on the far right. Other family members shown are, from left to right, Kate, Alma, Lee, an unidentified woman, Wes, John's father Sothenes, Clarence, Henry, and Epp. John married Katie Schwartz, who grew up on a farm on Martini Road in Delhi.

Henry B. Sieve Sr. came to the United States from Germany in 1890. One of his first jobs was as a railroad worker. He later ran a beer garden in Price Hill. Sieve came to Delhi in 1921 on an impulse. Sieve had made a lot of money selling cars in the neighboring community of Price Hill. One day he drove to Delhi to sell a truck to Herbert Greensmith and ended up buying Greensmith's farm at the northeast corner of Delhi and Greenwell. He opened Sieve's Service Station in place of Daniel Runck's blacksmith shop, and the business thrived, thanks to the rapid increase in popularity of automobiles. Sieve served as a Delhi Township trustee from 1928 to 1929, working to widen the roads and install gas mains throughout the township.

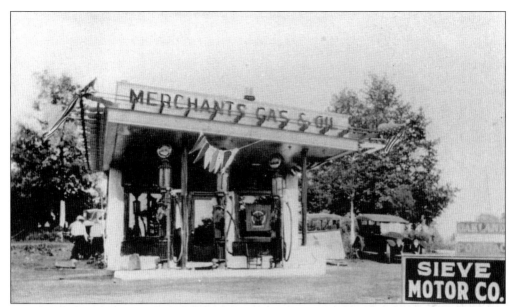

Sieve's business thrived throughout the 1920s, and he installed two gas pumps at the corner of the property. In 1923, Sieve's service station became the Oakland Motor Car dealership, and just a few years later it evolved into a Pontiac dealership. In 1930, Sieve sold the business and returned to the Price Hill area. The company continued to grow until space constraints forced it to move to its present location on Ferguson Road. The company still operates today and is the oldest Pontiac dealership in America.

Like his father, Henry Sieve Jr. also worked at the Sieve Motor Company on Greenwell and Delhi Roads. In 1928, he was the first junior member to be elected to the Republican Club of Hamilton County. He moved up in his father's company, becoming president of the Pontiac dealership, and continued in that capacity at the Ferguson Road location until his death in 1984.

This house belonged to the Adam P. Heintz family. Heintz's parents, Peter and Magdalena Clemons, migrated to the states from Germany. The couple settled in this area in the 1850s. Both are buried in the Our Lady of Victory Cemetery. Adam Heintz had three sisters, Kate A., Magdalena, and Mary, the last of whom married into the Backscheider family. Heintz's son, Tony, opened Heintz's Garage around 1920. The garage sold gas and repaired almost any car that came through its doors, including Model T's. Tony Heintz died in 1951, and John Bagel assumed ownership of the garage until his retirement in 1986. Adam Heintz was a Delhi Township trustee from 1916 to 1921. His daily life consisted of farming, a skill he learned from his father. Adam Heintz's family lived on Rapid Run Road, and some of their descendants still live there.

This is the Monterey Tavern at the corner of Rapid Run and Anderson Ferry roads. It was torn down in the 1960s. This building was originally the home of the Nathan Allen family, for whom the area was nicknamed Allen's Corner. The Allen District Schoolhouse, located on the south side of Rapid Run, west of Anderson's Ferry, still stands today.

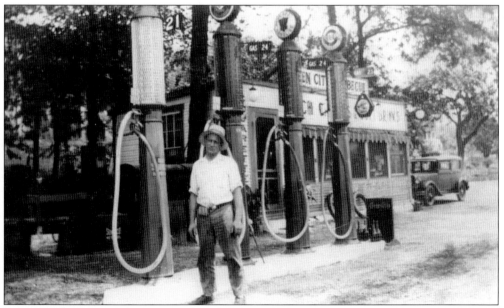

Robert Walker owned this gas station and the attached Queen City Bar-B-Que restaurant. This photograph was taken in 1929. In the subsequent three years, the business went through major changes as the popularity of cars increased, creating more demand for gasoline. The gas station soon offered more pumps, and the restaurant offered more delicious barbeque dishes.

This 1920s photograph shows some Ludwig family members outside their house on Neeb Road. The people in the photograph are, from left to right, Addie Wittich, Frank Felix, Caroline Ludwig, and Caroline's son Joseph Ludwig. John Conrad Ludwig and wife Caroline Tuchfarber Huenefeld started their married life on a 37-acre farm that belonged to Caroline's father, Steven Tuchfarber. Upon Steven's death in 1910, the farm, located on Rapid Run Road west of Neeb Road, was sold to Wendelin Ohmer. The profits bought a new seven-acre farm on Neeb Road at Five Points. The Ludwigs had five children, including Joseph (1889–1948), who was a Delhi Township trustee from 1926 to 1929.

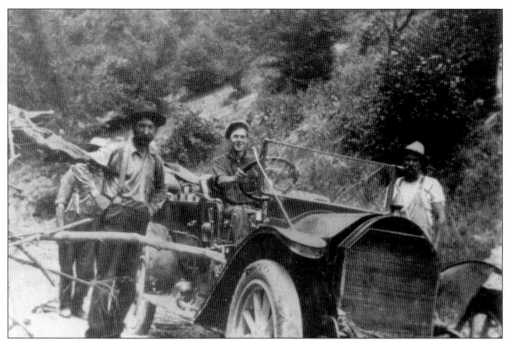

John Ludwig Jr. was born in 1862 to German native John Ludwig Sr. and wife Julianna Kessler Ludwig. In this photograph, Ludwig Jr. is on the far right hand side. Ludwig spent his childhood in a log cabin on Muddy Creek Road near Devil's Backbone, where the family grew vegetables. Ludwig rejected farming and joined the Delhi Township highway maintenance department. His main jobs were to mow grass and to keep the township cemetery spruced up, for which he was paid $8 a year in 1922. He also worked as a township constable for 32 years.

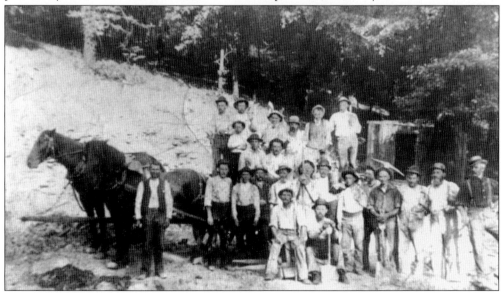

The Franke brothers joined together in the 1890s to form the Franke Brothers Road Construction Company. In this photograph, Henry Franke is pictured in front of the horse on the left side. Telephone service came to Delhi in 1902, and water was piped into the village in 1927. These public works surely gave the Franke brothers a lot to work on.

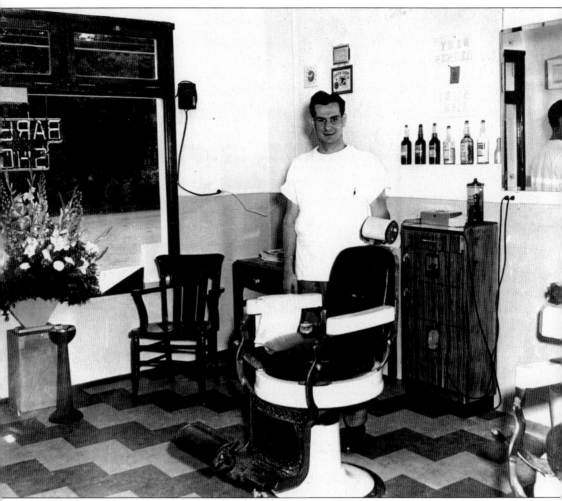

Bill Lape's barbershop is located at 402 Greenwell Road. This photograph was taken on June 12, 1951, the day the shop opened. Lape learned the skill of barbering while he was in the military, which he entered at age 17. His buddy was the barber for Lape's division, mainly because he had all the tools. When he left, he gave his tools to Lape, who took over the job. After Lape's duty was finished, he married Mary Rose, and he opened the barbershop 12 days after the wedding, soon after the couple returned from their honeymoon. The shop has been at the same address ever since. In 2005, Lape has one employee, Lloyd Thurston.

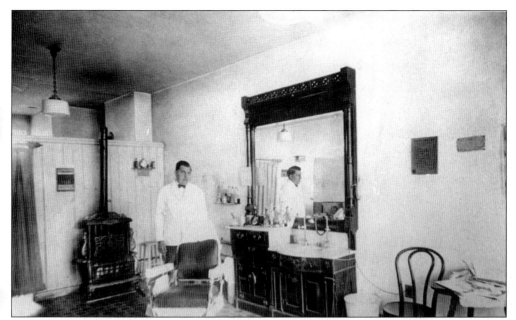

This 1929 photograph shows Carl Bosch standing in his barbershop. Bosch certainly tailored his business to suit his customers: He offered candy to the kids and cigars to the men who waited to get a haircut, a shave, or other services. The original address of the shop was 4539 West Eighth Avenue, but a newspaper advertisement announced the reopening of the shop in a new building down the street at 4472 West Eighth Street around 1940.

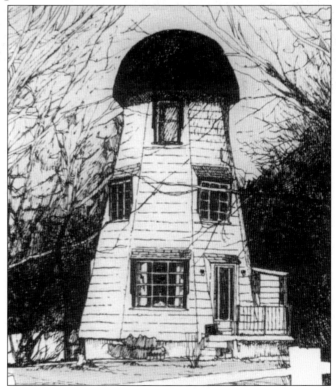

This windmill house was built by the Richard Linneman family in the 1930s. The couple visited Norway on their honeymoon, and when wife Margie later saw a photograph of a similar house, she asked Olaf Macke, an unemployed Norwegian ship builder, to construct the windmill part of the house. The house still stands on Foley Road. Husband Richard J. Linnemann operated a cleaning and tailoring shop at the same address as Bosch's barbershop. Linnemann also offered cigars for male customers, and he gave flowers to the women.

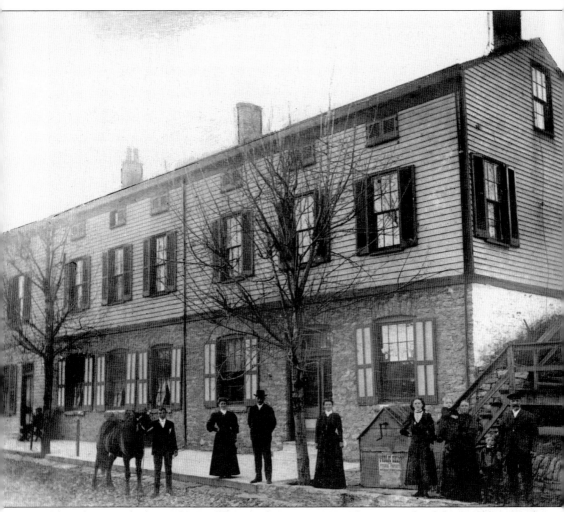

This photograph shows the Duebber residence in 1907. The patriarch of the Duebber family, Wilhelm Duebber, was born in Germany on September 5, 1856, and he arrived in Baltimore, Maryland, on May 24, 1884. He became a United States citizen on March 11, 1890, and he married Julia Ellerman, who was born in Germany on November 6, 1860. The couple settled in Cincinnati in the late 1880s after purchasing a 30-acre parcel of farmland. Wilhelm's name was changed to William, and he started three dairy farms on Delhi, Mount Alverno, and Paul Roads. The Duebber Dairy tried to deliver milk on a set route two times a week.

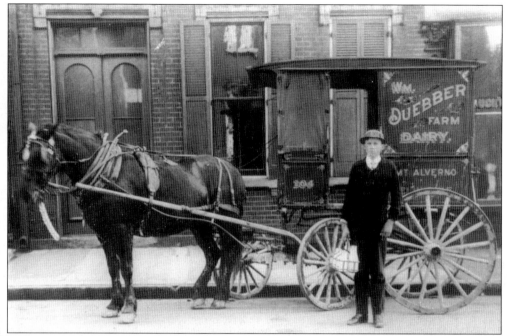

William and Julia Duebber had 10 children, one of whom was Adolph, pictured here. The Duebber dairy farms were passed down to three of their sons. William Jr. owned the farm on Delhi Road at the bottom of Mayhew Road. Harry operated the dairy located at Mount Alverno and Delhi Roads with his sons Walter and William. Adolph ran the farm located at Mount Alverno and Paul Roads, which stayed in business the longest. Adolph and his sons, Albert and Elmer, continued to run this farm until 1956. In 1972, the farm was sold to the Ryan Development Company and became the Paul Mano subdivision.

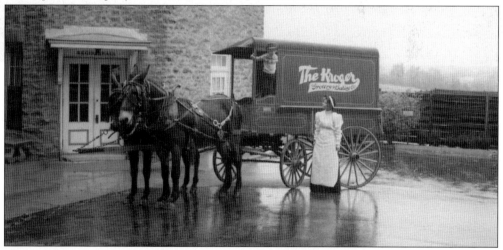

This red Kroger wagon is actually a reconstruction of Barney Kroger's first wagon, which he used for deliveries in the early 20th century. An early Kroger Store was located in the Sayler Park section of Delhi on Gracely Drive at Ivanhoe. In the 1940s, a tanker carrying gas crashed into the store, causing considerable damage. The store closed a few years later when a larger store was opened on Delhi Pike. The main employers in the area are Krogers, the Western Hills Retirement Village, Bayley Place, and Delhi Township, in that order.

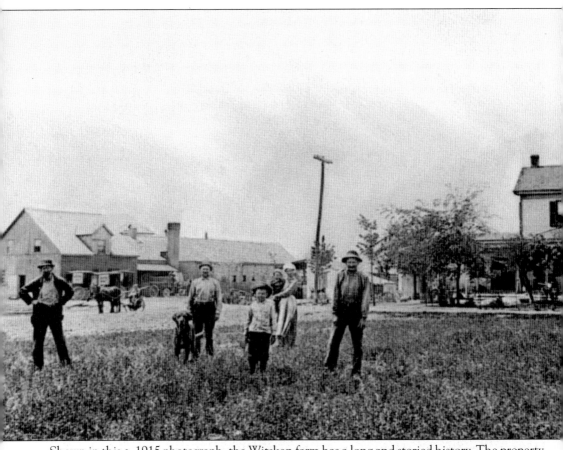

Shown in this c. 1915 photograph, the Witsken farm has a long and storied history. The property first came into shape when Ichabod Palmerton bought 160 acres of land in the section 12 geographical area that was owned by Jacob Burnet, James Finley, and William Henry Harrison. He paid $640 for the land in 1812, but he never lived on it. The land changed hands many times until Gerhard Henry Bruemmer purchased a 10-year lease from then-owner Bernard Henry Gerleman in 1888. Henry Bruemmer died in 1893, leaving behind instructions that his land be leased to his brother-in-law John Messink, who was to care for his children, among them Mary Bruemmer, as they grew up.

Joseph Franz Witsken was born in 1870 in Messingen, Germany. He and his brothers left Germany in 1894 and settled in the Fairmount area to work on the dairy farms there. After their wedding in 1900, Joseph and his wife, Mary Bruemmer, moved in 1903 into a house on the dairy farm owned by Mary's father on Cleves Pike in Delhi, and Joseph started the Witsken dairy. The couple had 10 children. This portrait was taken in 1905. When Joseph died in 1918, his real estate was priced at $20,000. In 1949, the farm was subdivided, and Marie Robbe bought the homestead.

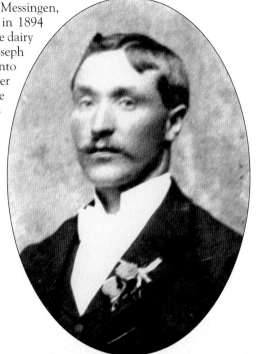

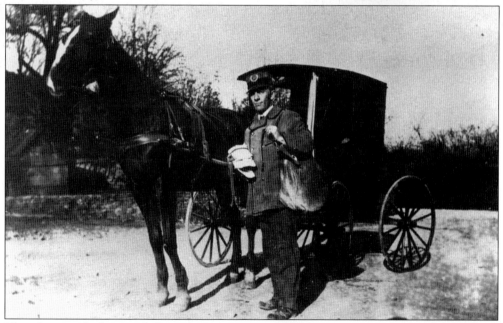

This photograph shows a dedicated postmaster out on his rounds. Several mail drop-offs were located in Delhi, but one of the most popular was at Mount Alverno school. Another worker often seen making the rounds was Dr. Edward Flinchpaugh. The medical doctor's office and home was on Rapid Run Road and Nebraska Avenue near St. Joseph Cemetery. The cemetery contains 175 acres and runs alongside Rapid Run Road. Archbishop Purcell purchased the land for the cemetery on August 17, 1854.

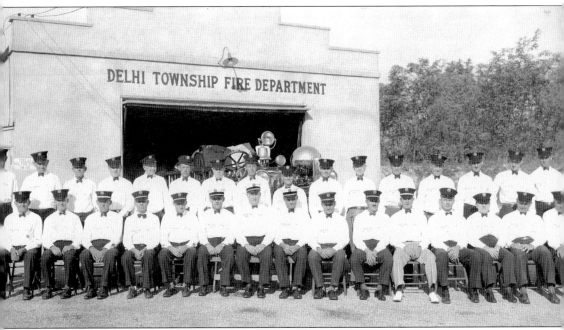

On May 3, 1929, the Delhi Township trustees set up a general fund of $100 for a fire protection account to cover fire emergencies within the township. But it was not until 1935 that the volunteer fire department began to take shape and grow. This photograph of the Delhi Township volunteer fire department was taken on October 16, 1938. Pictured from left to right are the following: (first row) Archie Pflanzer Sr., Wendelin Myers, Dave Klotter, Robert Zoellner, Jake Ohmer, Rudy Kusar, Joe Lampe, Albert Lipps, Joe Lipps, William Hengehold, Archie Pflaner Jr., Nick Pflanzer, George Lauderback, Anton Lipps, and George Hennegan; (second row) John Lee, Harry Selhorst, Leo Martini, Fritz Azmus, Art Koppenhoffer, Larry Huber, Fred Klotter, Phil Kortgardner, Harry Fay, John Imholt, Dave Imholt, William Eagan, Louis Richie, Matt Pettinger, Elmer Lipps, Fritz Lipps, Leonard Lipps, and Robert Lipps.

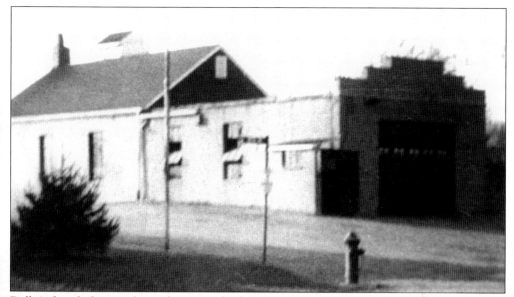

Delhi's first firehouse, shown here, was built on Neeb Road in 1934. In 1935, captains were assigned to local fire districts, and a siren was installed to call volunteers to a fire. A small hose and reel cart was also donated. Before the firehouse was built, or captians appointed, in 1931, the Delhi trustees encouraged residents in need of fire protection to call one of these five responsible citizens: F. E. Seitz, William L. Schneider, Robert Zoellner, Henry Reimerink, and Fred Morr. For their work and for the costs of the equipment used, $100 was allocated per hour of fire control; the amount was to be paid for by the general fund.

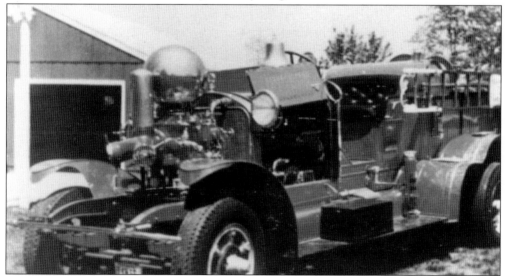

The 750-gallon Ahrens-Fox pumper, bought in November 1935, was the Delhi Fire Department's first fire truck. The fire department received its charter from the state that same year. The pumper was stored in the new fire department building at Neeb Road and Township Drive. Before the Neeb Road firehouse was completed in 1935, fire calls were routed to Klawitter's Saloon and Beer Garden. In 2005, the fire department employs 25 active members: 21 career personnel and 4 part-time personnel. The department owns three ambulances, two engines, and three paramedic units, which are staffed 24 hours a day by six personnel.

The Delhi Police Department got its start in this building on June 10, 1961, when the first police constables were appointed. The group of three policemen depended heavily on backup from the Hamilton County sheriff's office. A more formal police department was formed on August 14, 1963, with the creation of a police district. The first police chief was Howard R. Makin, who served from 1963 until May 28, 1996. The current police chief is John Coletta, and the department headquarters are now located at 934 Neeb Road in the Howard R. Makin law enforcement complex. The department also operates a substation at 4460 Glenhaven Road. Local artist Warren Stichtenoth drew this sketch.

The Reitmann grocery and slaughterhouse, owned by Joseph Reitmann, was located on Devil's Backbone Road near Ebenezer Road. The building burned on November 13, 1945. Pictured here are, from left to right, Walter Schawb, Joseph Reitmann, William Juengling, Edward Witterstaetter, and Bert Story. Joseph Reitmann and his family lived in a nearby house that was previously the Rafelty school of the North West Special District No. 9.

Two

GREEN THUMBS

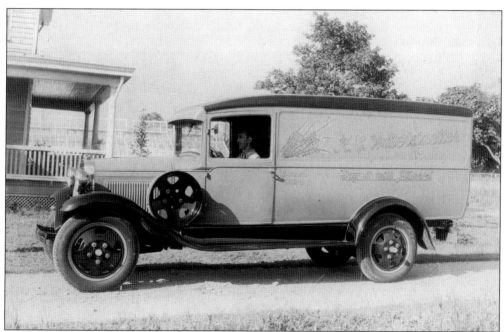

The present-day Witterstaetter Greenhouses were started by R.C. Witterstaetter, who opened his shop in 1919 on Covedale Road near Rapid Run. This 1931 photograph shows one of Witterstaetter's most prized possessions: a Ford truck he used to deliver flower orders. The store later moved to a property on Foley and Covedale Roads that once belonged to Henry Koester. R. C. Witterstaetter's sons Richard, Ray, and Paul took over the greenhouse after he died in 1974. Richard's son, Danny Witterstaetter, helps his father and his uncle Paul run the business today. The greenhouses are located at 643 Covedale Avenue.

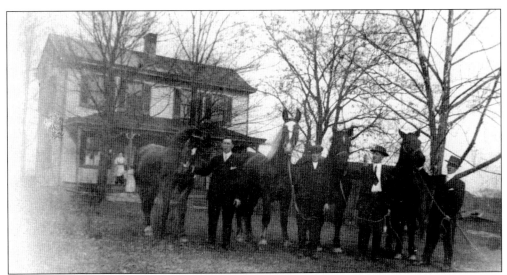

Ignatz Witterstaetter came to the United States in 1832. He brought his wife, Mary Elizabeth, and at least two children, Ignatius and Mary Ann. The family settled in 1837 on this farm in Delhi at Pedretti and Foley Roads. In this photograph, Mary Witterstaetter is barely visible on the front porch. Standing with their horses are, from left to right, Ed, Joseph, Edward, and Charles Witterstaetter. Ignatius married Louisa Kuperferle and had eight children. It is thought that Ignatius worked for a time as a printer for a German newspaper in Cincinnati. He also founded the first greenhouse in the area on his father's farm. After Ignatius's death in 1874, Louisa and their son Richard continued to work on the farm.

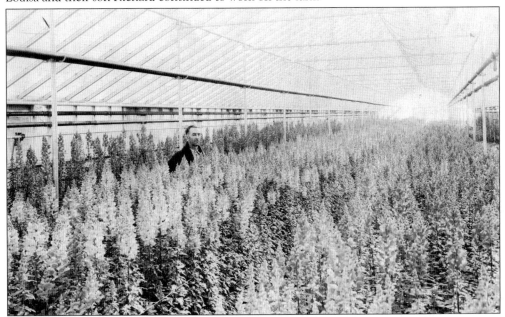

R. C. Witterstaetter originated 11 varieties of snapdragons, and this 1928 photograph shows him surrounded by them. His parents died when he was very young, around age 12, and his uncle Richard raised him. Richard's love of flowers must have rubbed off on R. C., because they both worked in the greenhouse business their entire lives. R. C.'s son Richard took over the Witterstaetter Greenhouses, and he continues to work there in 2005.

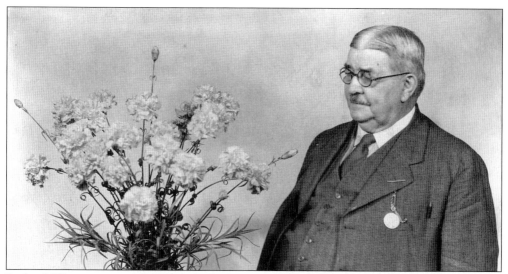

Richard Witterstaetter, R. C.'s uncle, built up the greenhouse by winning first place for the "most perfect carnation" in 1893. The award was given by the Society of American Florists, and Richard was deemed the "Carnation King." After his death in 1933, he left his business to his three nephews, Edward Witterstaetter and Ed and William Deller. William Deller took full control of his share of the greenhouse business in 1943 and changed its name to Wm. H. Deller and Sons. William Deller's sons, Don and Herb, took control of the business in 1964. They moved it to Rapid Run and Covedale Roads in the late 1980s; the business closed 10 years later. That second location is now a subdivision called Deller's Glen.

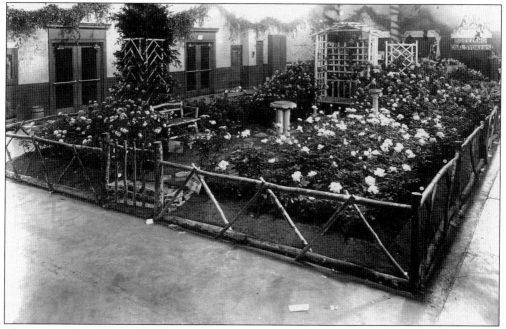

This 1930s photograph highlights R. C.'s gardening talents. This display was made for a flower show held in Music Hall. It is interesting to note that these flower displays were carted inside the hall and arranged there. The Cincinnati Flower and Garden Show continues to be a tradition in Delhi as well as in Cincinnati. In 2005, the show was held outside at Coney Island.

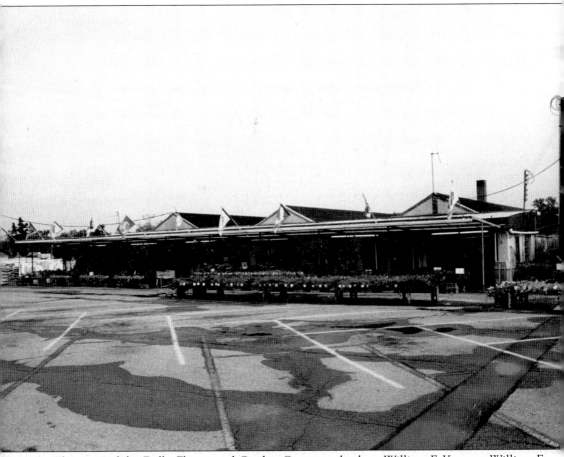

The roots of the Delhi Flower and Garden Center go back to William F. Krueger. William F., immigrated from Germany in 1865 and established a 20-acre farm along Anderson Ferry Road. He and his wife, Theresa, had five children. He died in 1929 at age 86. His son, also named William, married Sarabelle "Sally" Maddux, whose family owned greenhouses near Cleves Warsaw and Devil's Backbone Roads. William became a florist in 1947 at age 30. In 1960, he opened the Delhi Flower and Garden Center with his nephew, Robert Maddux. Sally and William had three children, Barbara Phillips, Shirley Fabing, and William F. Krueger Jr. Robert Maddux is now the sole owner of the garden center, which is one of the largest floral shops in Cincinnati. It is located at 5222 Delhi Road.

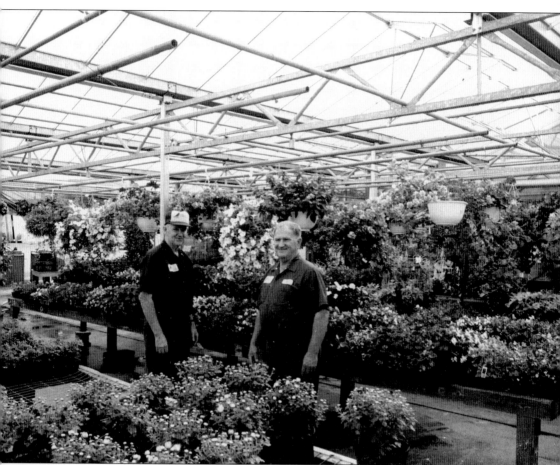

George Robben built this greenhouse in 1931 after marrying Agnes Bross. George's father, Anthony Robben, came from Germany in 1885 and bought land at Pedretti Road and Delhi Pike next to the farm of Joseph Schroer. Anthony wooed Joseph's daughter, Bernadina, and the two married in 1890. The couple owned 48 acres on Pedretti Road and 34 acres on Delhi Pike. They had five children: Bernard (Ben), Joseph, Mary, George, and August. Sons Ben and George worked on the family farm until 1929. Ben married Rose Haas, and he was a popular Delhi Township trustee from 1930 to 1933. The Robben greenhouse sustained a fire that completely ravaged the site and destroyed the flowers, but the retail and wholesale store survived. The Robben Florist and Greenhouses still operates on 352 Pedretti Road. In this photograph from August of 1994, George stands on the left next to Ray Robben.

Founded by Tom Oestreicher in 1988, Nature's Corner Greenhouses still operates in 2005. Located at 1028 Ebeneezer Road on the corner of Rapid Run Road, this retail shop sells foliage and flowering plants. Joseph Dornacher opened his wholesale florist business here in 1921. His sons-in-law, Earl and Ralph Schroer, took over before eventually selling to Oestreicher. This photograph was taken in 1993.

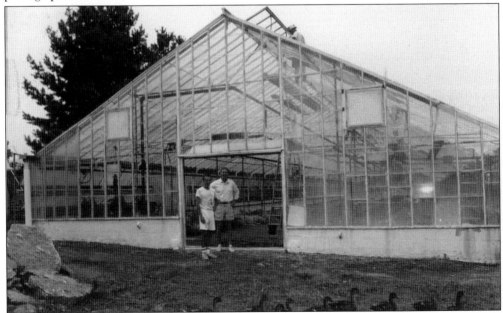

Roger Feist partnered with his father, F. J. Feist, to help run the Feist Greenhouses from 1966 to 1970. When F. J. retired, Roger bought out the remaining shares of the business, and the name was changed to West Hills Greenhouses. This building is at 701 Feist Drive, the present site of the flower shop. Roger stands on the right, and Bill Rindler is on the left. The greenhouse sold mainly carnations during the 1970s until foreign competition drove them out of that market. The West Hills Greenhouses now specialize in New Guinea impatiens.

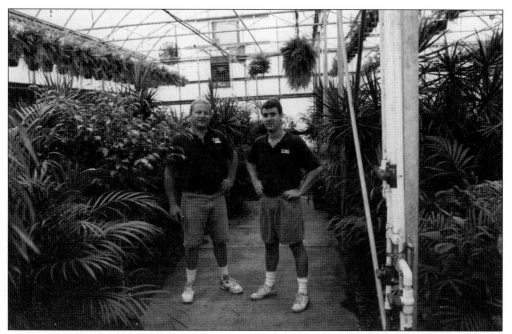

This August 1994 photograph shows Bill and Dale Lutz, but it was Lou Lutz who started the Tropical Foliage Plants wholesale florists on April 1, 1968. The shop stands at 5416 Foley Road. The Delhi area was once home to approximately 60 operating greenhouses; in 2005, only 7 remain.

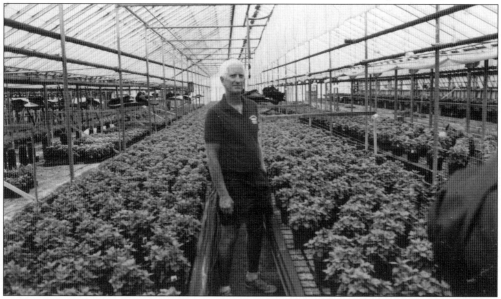

Douglas Friedhoff posed for this photograph in his greenhouse at Friedhoff Florists, Greenhouses and Nursery, located at 700 Anderson Ferry Road. In 2005, there are six other flower and garden shops in the Delhi area: Delhi Flower and Garden Center on Delhi Road, Robben Greenhouses on Pedretti Road, Witterstaetter Greenhouses on Covedale Road, Lutz Tropical Foliage on Delhi Road, Feist (West Hills) Greenhouses on Rapid Run Road, and Nature's Corner at the corner of Ebenezer and Rapid Run Roads.

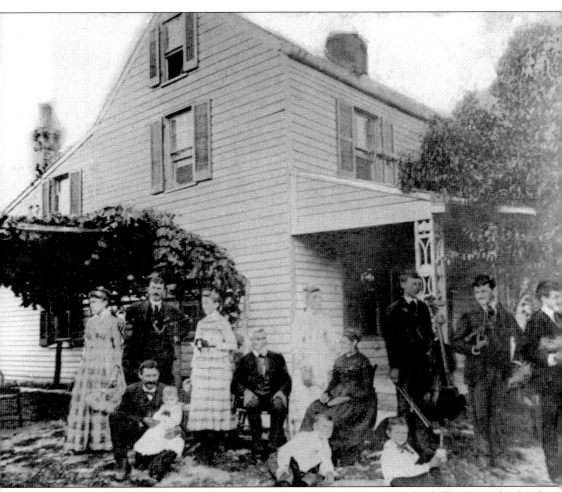

This photograph shows the early Feist family home on Pedretti Road. Phillip Feist, the family patriarch, immigrated from Germany in 1854 at age 20. He married Caroline Bosch in 1859, just four years after Caroline had immigrated to the area. In 1865, Phillip bought 22 acres of farmland along Pedretti Road from the Lipps family for $2,000. Phillip and Caroline had seven sons and four daughters. Their eldest son, Philip (born in 1872), and his wife, Elizabeth Lipps Feist, purchased 15 acres along Rapid Run Road in 1907 and raised 12 children there. Their eldest son, Richard, built greenhouses on the property in 1929. Philip and Caroline's second son, Joseph, married Theresa Ihle and had seven children. Their son, Joseph Jr. (1890–1940), settled on the family land at Pedretti Road. He married Gertrude Haas after he returned from fighting in World War I in Europe.

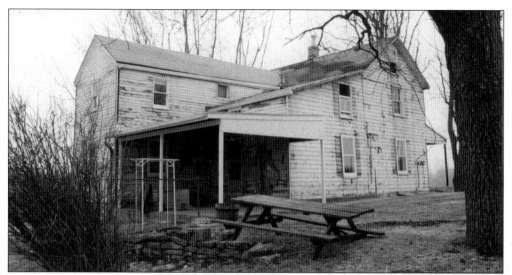

This more modern photograph again shows the Feist family home on Pedretti Road. The best-known Feist was not known for his flowers, but for his music. Robert Francis Feist was a world-famous opera conductor. Born on December 4,1928, he moved to 381 Greenwell Road around 1930 with his parents, Robert Valentine Feist and Mary Hautman Feist. Robert attended St. Dominic School, the College Conservatory of Music at the University of Cincinnati, and Indiana University, where he received his master's degree. He conducted his first concert in Spoleto, Italy, in 1955, and was an associate conductor of opera at the Stadt Theatre in Augsburg, Germany.

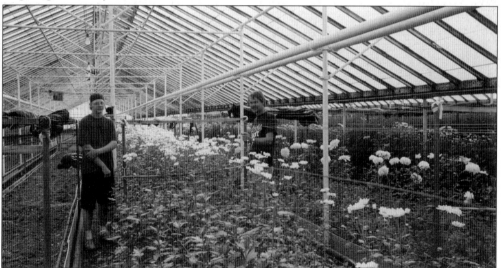

This August 1994 photograph of J. H. Wellen & Son florists belies the company's history. Entrepreneur O. B. Murphy was born in 1880 and founded the floral shop in 1910. The shop stayed in the Murphy family until 1942, when it was handed down to O. B.'s son-in-law, John Herman Wellen, who had married his daughter May. In 1972, the company name was changed to J. H. Wellen & Son. The store grew carnations from 1910 to 1974, then specialized in mums. In 1978, John Wellen, the son of J. H., took over. Here, John Jr. and John Sr. pose in front of their flowers at the shop's greenhouses on Greenwell Road. The business was sold and eventually closed in 2002.

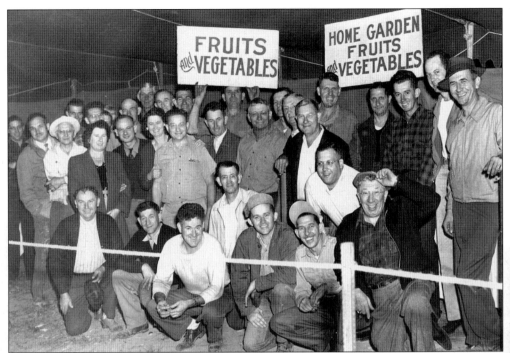

This photograph of Delhi garden growers highlights a sort of who's who of florists. Harry Duebber is kneeling on the far left with his hat in his hands. Also kneeling are, from left to right, Ed Winholtz, Dick Davis, Melvin Rueger, Charles Schmerker, and Ray Keis. Paul Koester is the first man on the left in the third row, and George Koester is five heads down from him. Joe Lipps and William Deller, both wearing glasses, are standing next to each other in the second row; William is holding onto a post. Right behind Deller are Bill Seitz, to the left, and Oscar Feist, the tall man to the right.

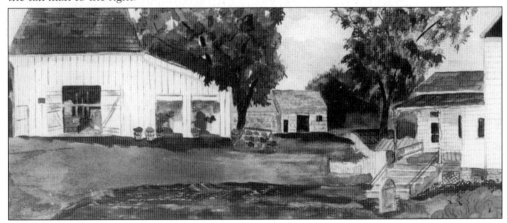

This 1957 drawing of the Huenfeld farm shows that it was a popular place to buy Halloween pumpkins and Christmas trees. Widow Anna Sophie Huenefeld's three sons, William, Herman, and Ernest, started the Huenfeld Greenhouse and Farm company. Anna made the long trip from Prussia to America with her sons and her daughter in 1848. Anna and the family settled in New Knoxville, where Anna died two years later. Her sons moved to Delhi soon after her death. The Huenfeld Greenhouse and Farm was demolished in 1974 to make way for the Delco center, which housed a Kroger and a K-Mart.

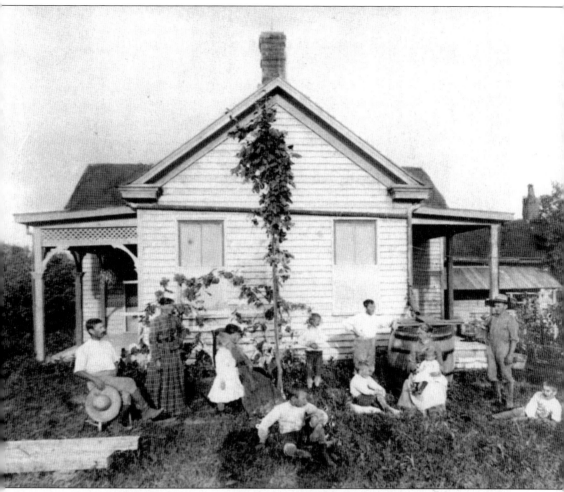

This photograph shows John Klotter and his family relaxing outside their house in 1905. John and his brother and sister, George and Sallie Klotter, came to the United States from Germany in 1852, but they are listed as "partners" on the 1900 census. George married a woman named Laura, and they had eight children. The family lived on Foley Road, where sons Fred, Dave, and Charles opened a greenhouse in the 1930s. The store at 5361 Foley Road, near Anderson Ferry, specialized in potted plants and bouquets for weddings and funerals.

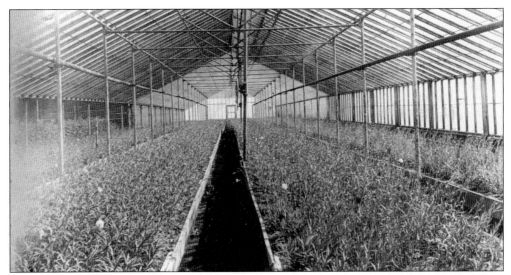

The Murphy greenhouse business, shown here with its rows of flowers, was started in 1910 at the corner of Cleves Warsaw and Devil's Backbone Roads. On July 29, 1812, Robert Murphy purchased 160 acres of land from Jacob Burnet, James Finley, and William Henry Harrison for $320. He settled on the land with his wife, Sarah, and son, William, who was born in New Jersey in 1797. William grew up to marry Mary Alice Miller. William and Mary's grandson, Louis F. Murphy, married his first cousin, Alice Murphy. Louis and Alice started the greehouse business in 1910 on Devil's Backbone Road. In 1927, the greenhouse moved to the corner of Devil's Backbone Road and Cleves Warsaw Road.

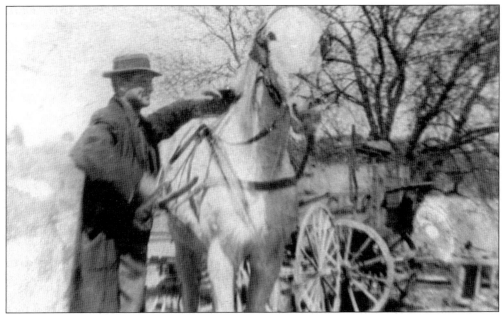

In this 1923 photograph, Robert Murphy prepares to make a delivery of flowers with his horse-drawn truck. Descendants of Robert Murphy operated three greenhouse businesses on Cleves Warsaw Road and another on Rapid Run Road; none of these business exist today. Another one of William and Mary Ann's grandsons, Oliver B. Murphy, opened a greenhouse on Greenwell that eventually became the J. H. Wellen & Son greenhouse; it, too, is no longer in business.

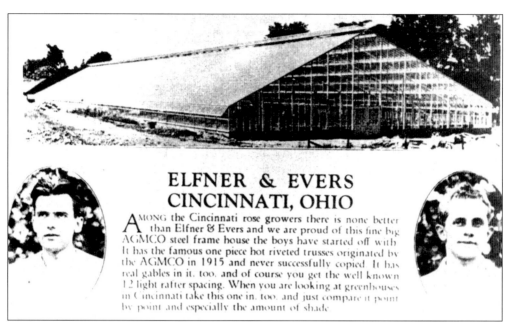

This ad appeared in *American Greenhouses*. As the ad states, Charles Elfner and Carl Evers were popular rose growers in the early decades of the 20th century. The pair owned the largest greenhouse in the area that specialized in growing roses. The business was located on Delhi Pike east of Neeb Road. Elfner and Evers bought Henry Kurler's farm in 1921 and turned it into a "state-of-the-art" greenhouse operation. They grew flowers here for more than 50 years; then, in 1971, they sold the company to Judge Rupert Doan. Years later, the name of the business was changed to Hidden Heritage, and, later still, to Something Special. In 2004, the College of Mount St. Joseph opened a sports complex on this site.

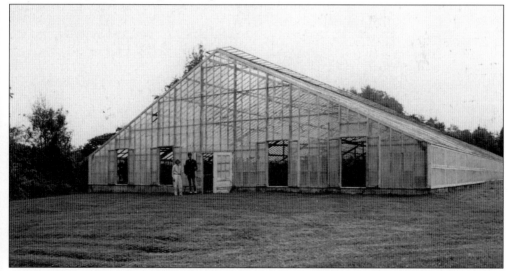

Sandy Runk bought this Delhi Road greenhouse in 1981 from Judge Rupert Doan, who had owned the business for 10 years. Before him, Charles Elfner and Carl Evers had run the greenhouse. In this 1994 photograph, Brian Nixon and owner Sandy Runk stand outside the business. The greenhouses were razed in 2004 to make way for the College of Mount St. Joseph athletic complex.

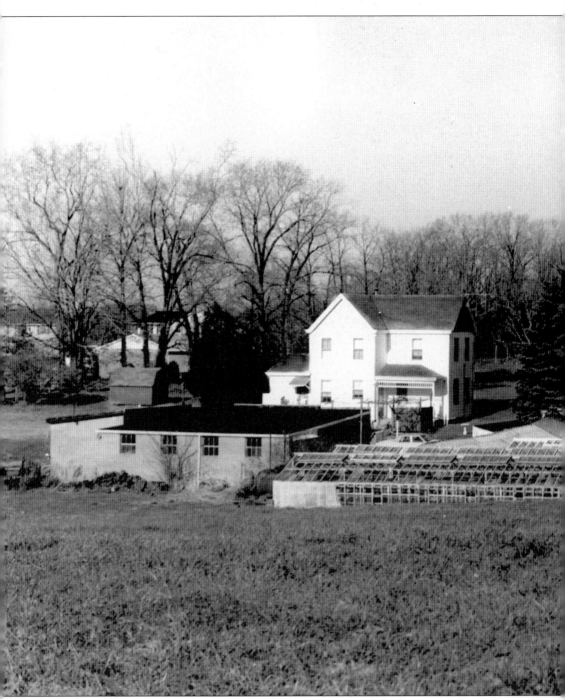

Fred "Fritz" Koester and wife Henrietta were the first owners of this home on Foley and Covedale Roads. On June 1, 1866, the penniless 21-year-old Fritz stowed away on a ship that was leaving Hamburg bound for America. He passed the time playing the concertina for other German passengers. Once in America, he quickly fell in love with and married Henrietta Wedig. The couple rented a farm at Greenwell and Mayhew Roads until Fritz saved enough money from his prosperous masonry business to buy the land seen here. Fritz and Henrietta had 12 children.

Their son Henry (1872–1942) married Minnie Rutenschroer, and the couple owned a house on Covedale Road near Rapid Run Road, close to his parents. Henry was known for growing violets and being able to "divine" water with a peach branch. Henry's son Clarence inherited this ability, but he lost it after replacing several teeth with a gold plate. This land was later owned by William Schaefer, who specialized in growing lilies. Schaefer sold the land to florists William Deller & Sons. Today, the site is a subdivision named Deller's Glen.

Virginia, Dolores, and Angela Selhorst stand in front of the family greenhouse in 1928. John and Catherine Brunck Sehlhorst planted their roots in Delhi in 1884, when they built a house on Cleves Warsaw Pike near Muddy Creek Road at a cost of $900. John and Catherine had two children: Harry lived on land next to his parents' house, and Frank opened a greenhouse on Neeb Road in 1925 with his wife, Dora Westrich Sehlhorst. Frank specialized in growing carnations for many years, but after one year of losing an entire crop, he switched to growing geraniums, and soon the store had moved on to growing bedding plants. Frank's sons Bob and Linus took control of the business in 1957. Bob's son Robert also worked in the greenhouse. Sehlhorst florists often donated potted plants to local beautification projects, but the business closed in 2001. Some family members spell their name Selhorst, but both spellings are correct.

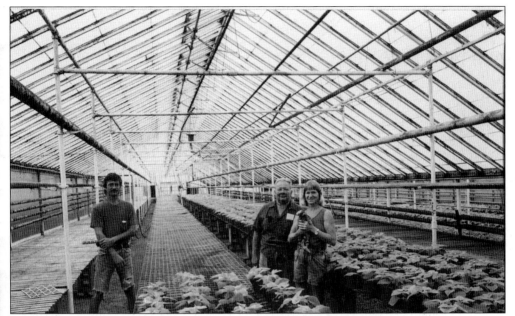

Broxterman Florists opened in 1967 at 511 Greenwell Road with Bill Broxterman at the helm. The store specialized in bedding plants. Bill Broxterman began his career at Charles Witterstaetter's florist shop on Anderson Ferry Road at age 16. The Scherer family, including George and Al (father and son), previously lived on this land. It is thought that Al Scherer also operated a greenhouse on this property. This August 1994 photograph shows worker Tim Tierney and owners Bill and Sandy Broxterman.

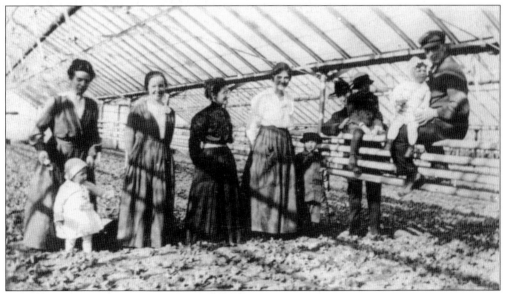

This 1917 photograph shows the Seitz Greenhouse on Rapid Run Road, which was founded by Edward Seitz. He was always interested in growing flowers, but he became especially interested after he experimented with putting his father's garden under glass in 1912 to help the crops grow better. Eventually, three acres were put under glass. Edward grew other general farm crops and eventually started specializing in tomatoes.

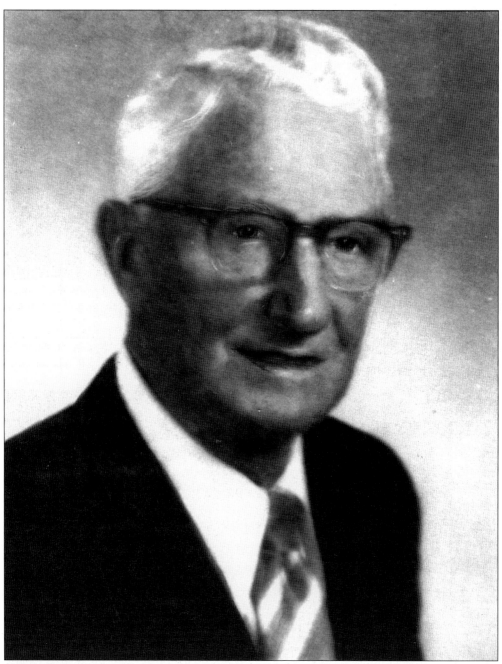

Edward Seitz (1890–1973) was truly a farming pioneer. He built up his greenhouse into the largest in southwest Ohio in the 1970s. It was awarded this title because it produced an average of 60,000 eight-pound baskets of tomatoes per year. Seitz was also president of the Hamilton County Vegetable Growers Association of America, and he was bestowed with the title of "master farmer" in 1928. In 1972, one year before his death, he was the first living person inducted into the Ohio Agriculture Hall of Fame. When Seitz was not working with his crops, he could be found teaching Sunday school or serving as a trustee at the Westwood First Presbyterian Church.

Frank Deller stands in his garden in 1933. The founders of Deller Greenhouses were Louise Witterstaetter and her son Richard, who took control of the business in the late 19th century. In 1933, the company was passed off to Richard's nephews Edward and William H. Deller. It was William who worked there the longest, and in 1960, his sons Don and Herbert joined him in the business. That same year, the name of the business was changed to William H. Deller & Sons. The greenhouses closed, and the property, located at Pedretti and Foley Roads, was sold for condominium development in the 1990s.

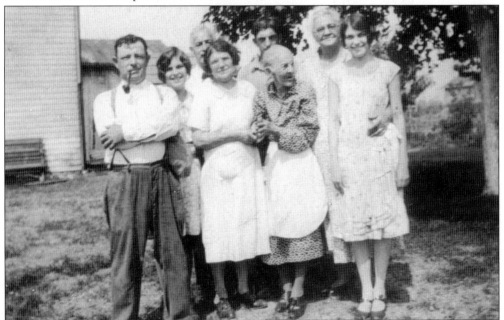

The Frank Deller family stands outside their home in 1932. Pictured are, from left to right, the following: (first row) Frank L. Deller, daughter Rosella Deller Nauman, his wife Julia Deller, Grandma Eddy Deller, and his daughter Agatha Deller; (second row): identified as Herman Hoffman, a disabled boarder who did odd jobs around the house, Ed Deller, and Grandma Agatha Nieder.

45

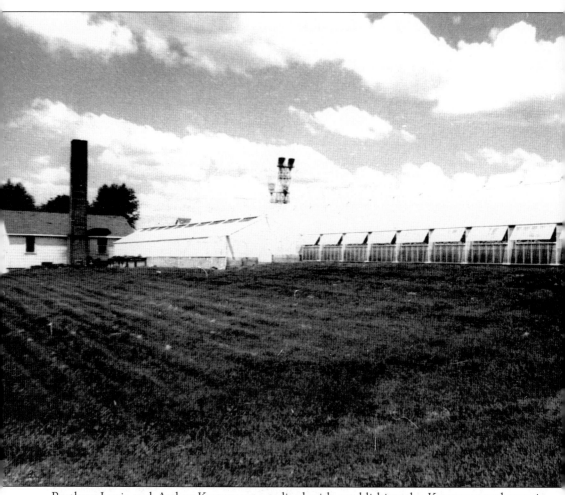

Brothers Louis and Arthur Kramer are credited with establishing the Kramer greenhouse in 1911. The business was located on Delhi Pike; a Kroger now stands on the site. The brothers specialized in carnations, snapdragons, chrysanthemums, and sweet peas. During World War I, they helped the war effort by growing vegetables instead of flowers. In 1929, they broke up their partnership, and Arthur remained owner of the original property. Louis moved down the street to open another greenhouse near the property of the present-day Delhi Flower and Garden Center. Arthur's sons Clarence and Clifford took over the business after World War II. They sold it in 1970.

Three
SPIRITUALITY AND SCHOOLS

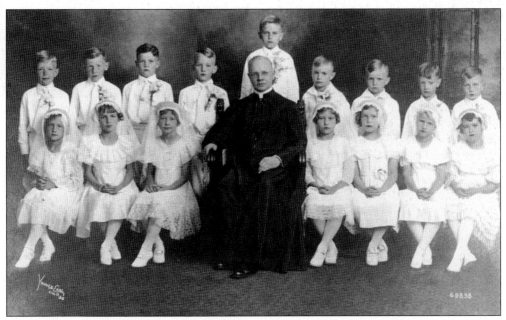

This is a photograph of the St. Dominic first communion class of 1936. Pastor Father Grimmelsman sits in front. Communicants pictured are, from left to right, the following: (first row) Ruth Stucker, Lillian Feist, B. Becker, Alberta Scherer, Mary Elaine Lipps, Eileen Juengling, and Mary Habig; (second row) George Robben, Arthur Haas, Robbert Robben, Jack Lipps, Nicholas Clemens, Don Fehr, Richard Schneider, Maxwell Lammers, and Daniel Conrad.

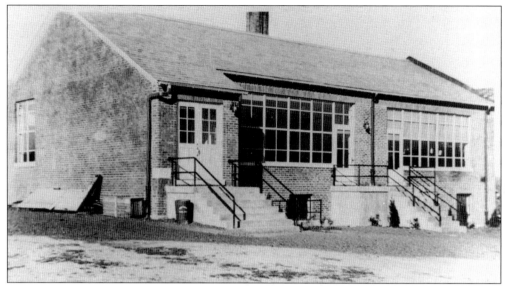

The idea to build another Catholic parish in Delhi was conceived in the autumn of 1933. For two years before this building was built, parishioners held services at the Mutual Aid Hall on Greenwell Road, for which they paid $25 in monthly rent. Bernardina Robben donated land for the first St. Dominic parish, which was also used as a school. Her husband gave up two years' salary as a township trustee, which totaled $500, to support the building fund. The Sisters of Charity worked as teachers at the school. St. Dominic joined the three existing Catholic churches in the township: Shiloh, Our Lady of Victory, and St. John's.

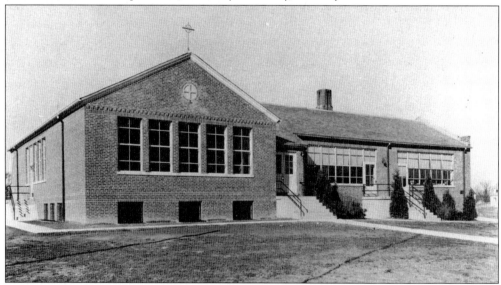

This is the St. Dominic chapel addition built in 1938. The first Mass was celebrated on October 29, 1933. The first collection amounted to $20—not quite enough to pay the mortgage. Father Grimmelsman served as pastor for 36 years. The school opened in September 1934 with 3 teachers and 94 students. The next year's graduating class included five students: Clemens Wolfer Jr., Louis Otting, Maurice Feist, Matthew McDonough, and Louis Lipps. In June 1951, Louis Lipps was the first parishioner to be ordained a priest. On June 2, 1957, a new church was dedicated. St. Dominic celebrated its 50th anniversary in October 1983.

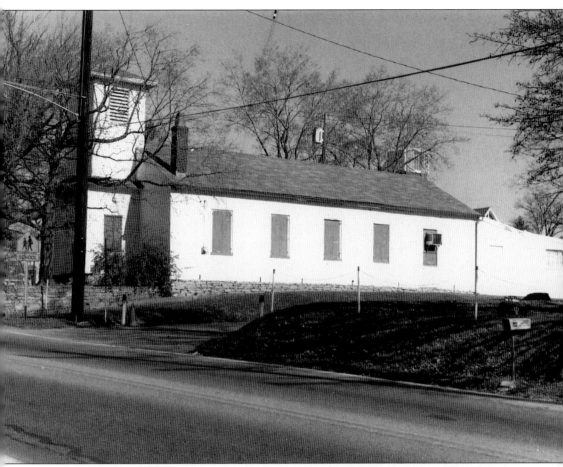

The Shiloh United Methodist Church, built in 1830, was one the first churches in Delhi. Before the church was built, Methodist parishioners met at the homes of Peter Williams and John Shaw. Williams changed that when he donated one acre of land for a church and cemetery. He also made the 43,000 bricks needed for the church's construction and furnished 32 perch of stone. Shaw contributed 4,500 feet of lumber. The cemetery was constructed around the site of the earliest recorded burial, Roxanna Harding, who died in 1822. The Shiloh United Methodist Church still stands at the corner of Anderson Ferry and Foley Roads.

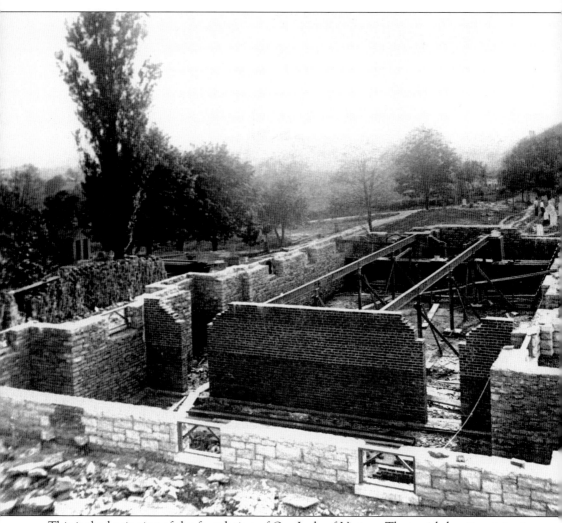

This is the beginning of the foundation of Our Lady of Victory. The parish has its origins in a Catholic congregation that was started by Father Henni in 1834. The first meeting was held on February 9, 1834, at Phillip Owens's house. By December of the next year, the congregation had 65 members. In 1841, Adam Emge donated a half-acre of land on Rapid Run Road east of Ebenezer Road and south of Neeb Road. The following year, a log chapel and school had been built. Rev. John M. Henni, a pastor at Holy Trinity parish on West 5th Street, also offered Masses at this log cabin. In 1844, the parish incorporated as St. Stephen's. In 1852, the log church was dismantled, and a new brick church was planned for construction on Neeb Road.

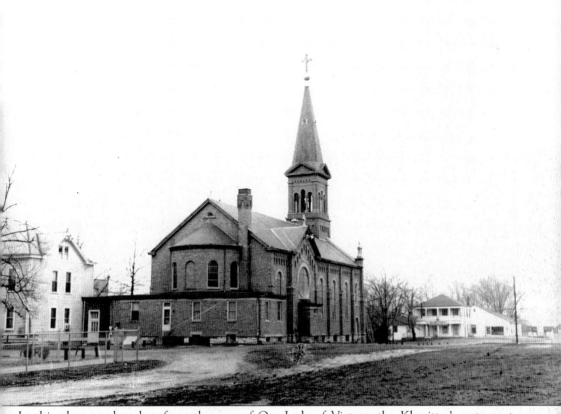

In this photograph, taken from the rear of Our Lady of Victory, the Klawitter's restaurant and grocery store can be seen across the street in the white house. After the log church was dismantled, John Gerteisen and Blasius Schweizer donated three acres of land on which to build a new church, which opened to parishioners in 1853. The German Catholic parishioners named the church Maria Zum Siege. The Sisters of St. Francis of Oldenburg, Indiana, filled the teaching positions in 1892. German, religion, and arithmetic were the main subjects taught during these early years. Parishioners built a new school building in 1898 to accommodate the large number of students. Another church was built in 1908, which was replaced with a new church built in 1980. The church is called Our Lady of Victory today. Rev. Joseph Sund was the pastor for 45 years; he passed away on October 15, 1952.

Eighth Grade Commencement

OF THE

Williams and Myers Schools

—— OF DELHI TOWNSHIP ——

WILL BE HELD AT THE

FARMERS UNION HALL

Delhi Pike and Greenwell Avenue

ON

Thursday Evening, June 12, 1919

Exercises to begin at 8 P. M.

TEACHERS

Myers School

E. S. STRATTON

Williams School

F. R. JORDAN, Principal

SYBIL ESLINGER, Assistant

PLINY A. JOHNSTON, County Superintendent of Schools

O. H. BENNETT, District Superintendent of Schools

Music Furnished by Carrier's Orchestra

This 1919 graduation program shows that the students in both the Williams and the Myers schools graduated together. The Williams school graduates were Julia Duebber, Arthur Broxtermann, Thelma Hunsicker, Sophie Meyer, Agatha Deller, William L. Schneider, Brunette Masminster, and Ruth Maddux. The Myers school graduates were Emma Riess and Lillian Schuster. The orchestra played several musical numbers, the audience sang "The Star Spangled Banner," graduate Ruth Maddux sang "I Was So Glad I Was Here," and graduate Julia Duebber sang "Entertaining Her Big Sister's Beau." William L. Schneider and Agatha Deller both gave recitations, and Rev. B. W. Carrier said the benediction.

The graduates of the class of 1910–1911 included Lawrence Maddux, Harry Huenfeld, Joseph Bruening, Joseph Allen, Joseph Wickhan, Alma Betz, and Marguerite Runck. Their principal was B. J. Maddux, and his assistant was Alvina Kelsch. The class motto was "Labor has sure reward," and the school colors were "old gold" and blue. The program states that the "Address and Presentation of Diplomas" was given by E. W. Wilkinson, principal of the First Intermediate School in Cincinnati. Members of the board of education included president Daniel Runck, treasurer Richard Witterstaetter, clerk Louis Hunsicker, Willis B. Snell, and John Schraer.

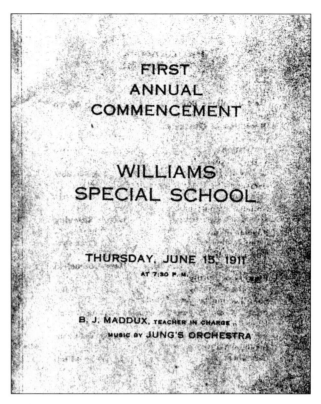

Carson School in District No. 6 was named after John Carson, who lived in this c. 1810 house on Rapid Run Road near Greenwich Avenue. For many years, Carson was the only teacher in the Western Hills area. Between 1828 and 1833, five public schools were organized throughout the township. The Ohio public school system was officially organized in 1829.

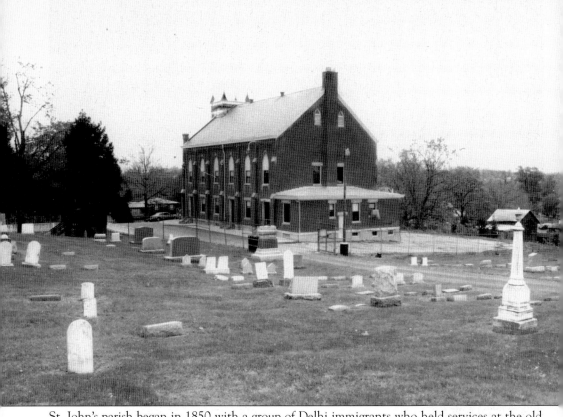

St. John's parish began in 1850 with a group of Delhi immigrants who held services at the old Runck schoolhouse on Rapid Run Road. In 1899, they built a brick church on Neeb Road. In 1926, the church was enlarged, and a Moeller pipe organ was added. The group built a more modern circular church on adjacent property in 1969. This is a photograph of the old church, which is used as a day care today; the steeple was removed for safety reasons.

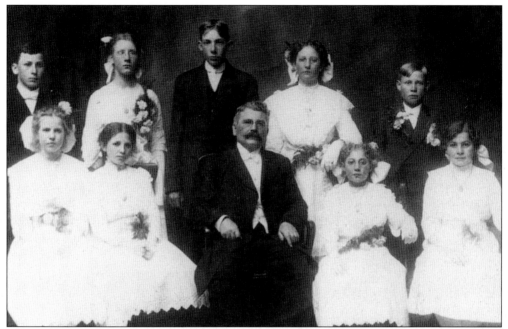

Seated in the center of this 1913 photograph is Reverend Schoewandt, who was the pastor at St. John's from 1907 to 1917. Also pictured are, from left to right, the following: (first row) Julia Runck, Elizabeth Riess, Minnie Meyer, and Dora Betz; (second row) Tom Brater, Irma Duerr, John Schroer, Mamie Becker, and Herman Meyer.

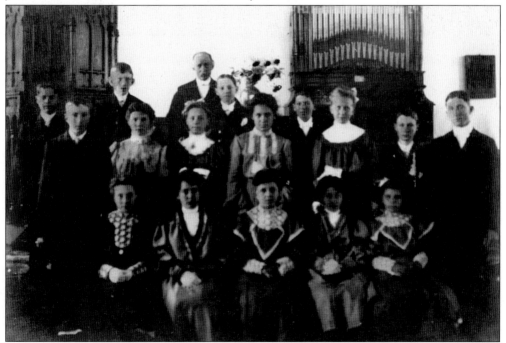

St. John's had a thriving choir full of young people in the early decades of the 20th century. Edward Seitz is on the far right. The first pastor to oversee St. John's was Reverend Pohlmeyer. He had his own parish in Sedamsville, but he commuted to Delhi to preside over services here.

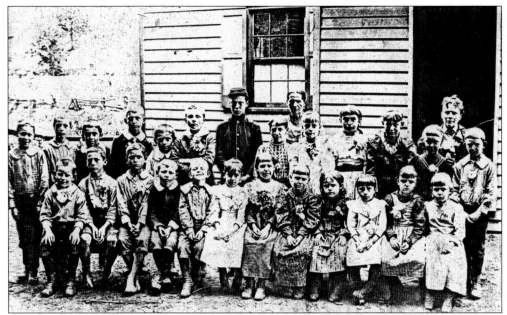

This c. 1880 photograph is of an early class at the Allen District School, located on Rapid Run Road west of Anderson Ferry Road. The teachers were Ebenezer Hazard and his wife, Margaret. The couple lived for a time on the corner of Anderson Ferry and Rapid Run Roads; they later moved to the corner of Neeb and Cleves Warsaw Roads. In later years, this school changed its name to the Hazard School. It closed in the 1890s.

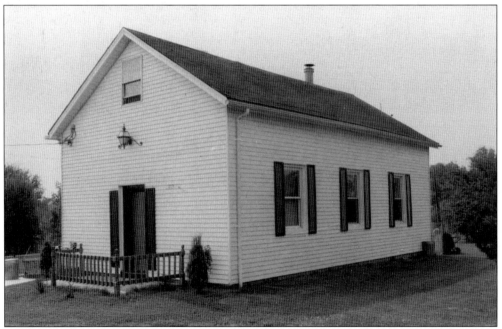

This mid 1940s photograph shows the former Runck Schoolhouse at Rapid Run and Ebenezer Roads. The school opened in 1849 and closed when Northwestern School opened in the late 1890s. The Warsaw District No. 1 school, another local school, opened in the 1840s and on Rapid Run Road east of Nebraska Avenue.

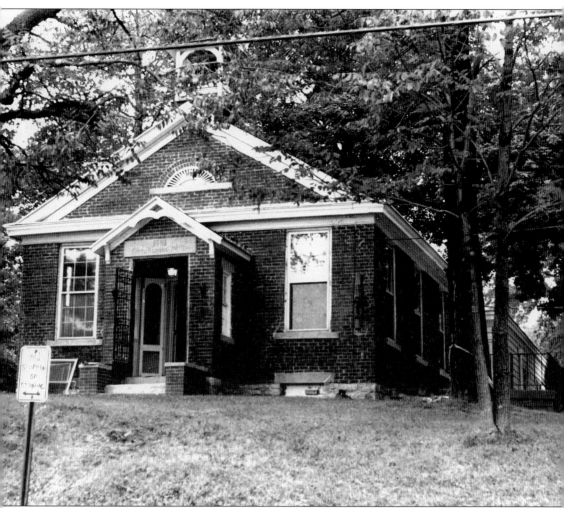

This is the Myers District School in 1891. The school also served as a town meeting hall, where trustees met to discuss township business. A log house served as the first schoolhouse on the site; the second structure was built of handmade bricks, and the third was built of manufactured bricks. The school was in Delhi's District No. 3 and was named after Cornelius Myers, one of its trustees. It officially opened on October 4, 1841. The school closed in 1926 when it merged with two others to become the Delhi Township School. In the early years, the school went through many different teachers, among them A. P. Haile, C. P. Bishop, Albert Essex, C. R. Handing, A. W. Rhodes, and John Stout. The average teacher's salary was approximately $1 per day. Perhaps these early teachers needed more education than the students. John Stout, a teacher in 1849, wrote, "The whole number of scholars for the quarter was 19, number of males 2 and females 15."

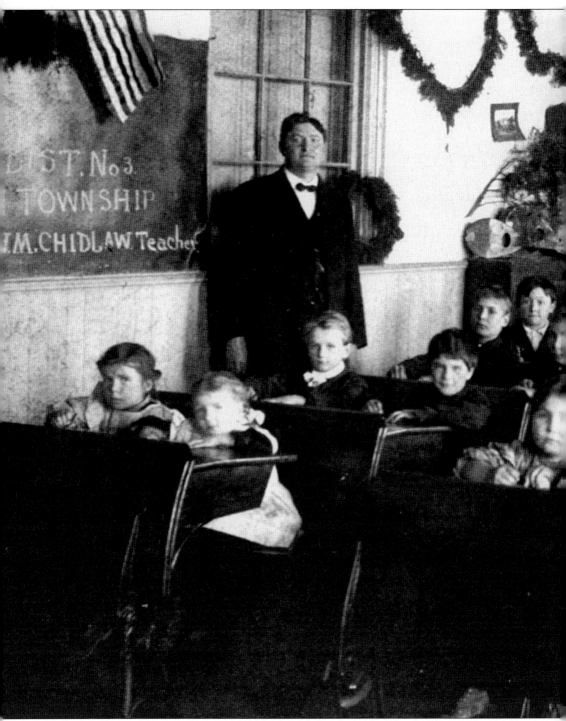

This is a classroom of students at the Myers District School with their teacher, William Chidlaw. Chidlaw and other teachers in the early decades of the 1900s taught history, English, geography, arithmetic, reading, writing, and spelling. Chidlaw studied engineering at Miami University, but when an opportunity to teach opened up at the Myers school, he took it. He was an educator for

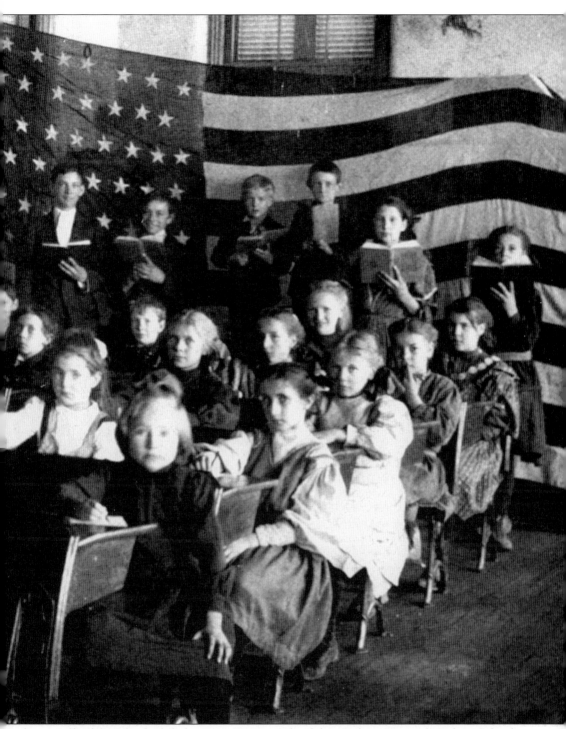

the rest of his life. After he left the Myers District School, he taught at Riverside Colony School and the Fifth District School. He was then appointed assistant principal of the Sixth District School. He was later an assistant principal at the Sands School. In 1918, he became principal of Sayler Park School.

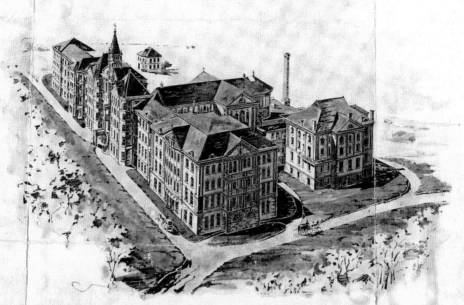

This 1891 drawing of the St. Aloysius Academy, a boarding school for boys, was used on a brochure sent out to the general public. The academy was located at the motherhouse of the Sisters of Charity, located at Delhi and Bender Roads. A newspaper clipping from that year states that the academy offered "superior advantages to boys, to obtain an education under the most refining influences." German was taught in the lower grades, and Latin was taught in the higher grades. In order to be accepted, pupils had to show that they had a high moral character and social standing. Tuition was $150 for the 10-month school year. Private lessons in music and drawing, as well as physicians' fees, cost extra. Cedar Grove Academy for girls was located just five miles east of St. Aloysius.

The Brothers of the Poor of St. Francis Seraph moved to the Delhi area in the late 1860s. The area was formerly called Mount St. Peter, but the brothers renamed the area Mount Alverno because they believed their patron saint received the stigmata on Mount Alverno. They started a boys protectory, pictured here, in 1869. Many of the students were orphans and troubled boys who were not sent to the Ohio State Reformatory.

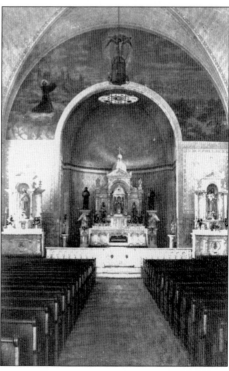

The chapel at Mount Alverno became more and more crowded as the brothers ran out of room for all of the boys who lived there. In 1871, the brothers moved the school to the W. Q. Adams estate. The new grounds held administrative offices, an infirmary, and Sacred Heart Parish, which acted as both a church and a school. In 1906, a fire broke out, destroying most of the school. The boys and brothers could not return until June 1907.

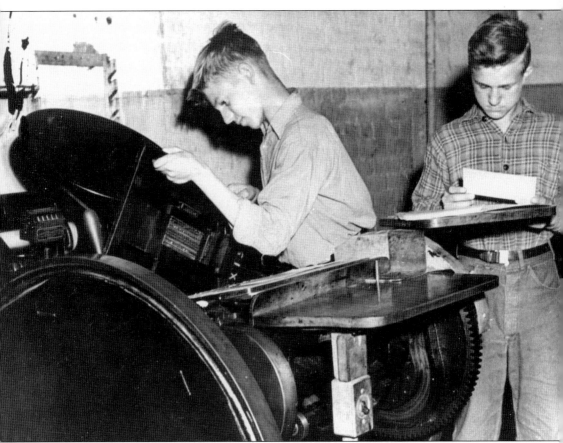

These two young men are working hard at learning typography and print practices in the Mount Alverno print shop. The brothers taught the boys skills they could use to get jobs after leaving Mount Alverno. When not learning from books or professional practice, the boys helped with the daily chores. Duties included cultivating the estate's vineyards and quarrying limestone to be used in the construction of the school, chapel, and additional living quarters. The school reached its peak in 1880, when more than 200 boys were living at Mount Alverno. In 1972, the school's expenses exceeded its income, and the brothers were forced to sell the property to developer Crest Communities. Crest demolished the building to make room for a new subdivision.

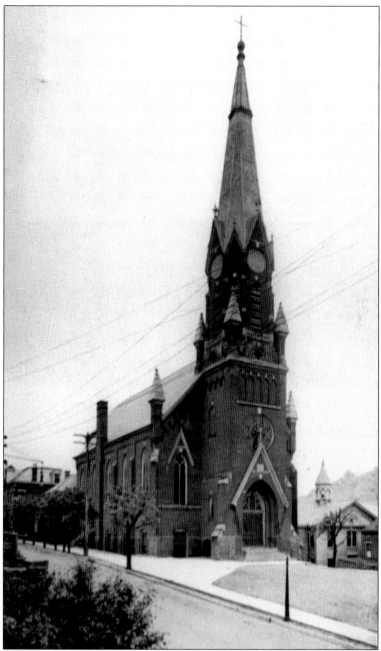

Our Lady of Perpetual Help church, a Riverside landmark, is visible from River Road. The church was built after an argument between German and Irish settlers who worshipped at the church of St. Vincent de Paul. The Germans pushed to build a school that would be incorporated with the church, and the Irish told them to build their own church if they wanted a school. On May 12, 1878, the Germans dedicated their new church, Our Lady of Perpetual Help, on Sedam Street. The flood of 1883 destroyed the church, but, thanks to the efforts and expense account of Conrad Miller of Price Hill, a new church was built. It was dedicated on May 5, 1889, and it still stands on Steiner Avenue.

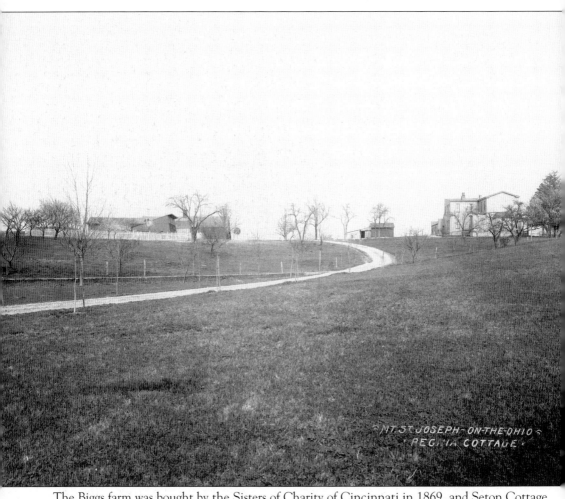

The Biggs farm was bought by the Sisters of Charity of Cincinnati in 1869, and Seton Cottage was built here in the early 1870s. The area was referred to as Mount St. Joseph because of the large seminary already established there. The cottage's porch was removed in 1947. The St. Joseph House, which was also built in the early 1870s, later became the motherhouse. Travis Profitt later resided in this house until it was razed in the 1970s. Byrne Cottage, built across the road from the St. Joseph House, was used by two priests, Father Grimmelsman and Father O'Regan. The housekeeper was Father O'Regan's sister. College students lived in Bryne Cottage during World War II, and it was later a residence for the sisters of Sister Alice Marie O'Meara. The house was torn down when Delhi Road was widened in the 1950s.

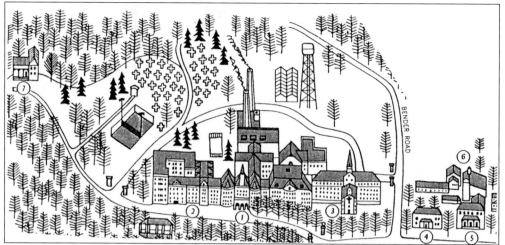

This drawing shows the grounds on which the Sisters of Charity lived, worked, and farmed. Pictured are the following: (1) the motherhouse in 1884 (construction went from 1881–1883); (2) the Seton House of Studies in 1920; (3) Mother Margaret Hall in 1949; (4) St. Martha Hall; (5) the original building, called St. Joseph Hall, in 1869; (6) the farm; and (7) the farmhouse.

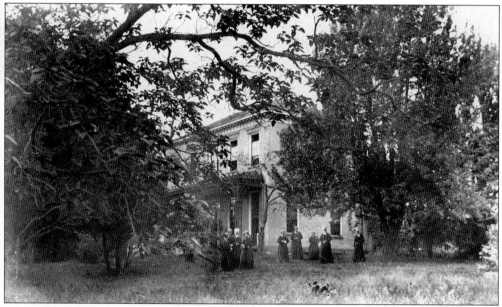

When the Sisters of Charity first arrived in Cincinnati, on October 27, 1829, they settled downtown on Sixth Street near Sycamore Street. This photograph, probably taken in the early 1870s, shows the Biggs farmhouse, which became the Sisters' Novitiate. Some of the sisters and novices stand outside of the house. Before the sisters moved to the 97-acre Biggs farm in 1869, the property was home to pigs, ducks, and sheep.

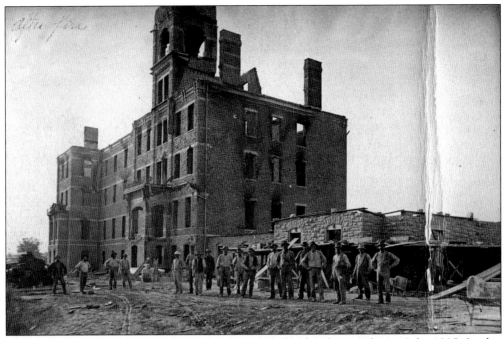

The sisters lived peacefully in the motherhouse until a fire destroyed it in July, 1885. In this photograph, firefighters stand outside of the wreckage. Although the fire ravaged most of the building, an indoor statue of St. Joseph sitting with the child Jesus did not burn.

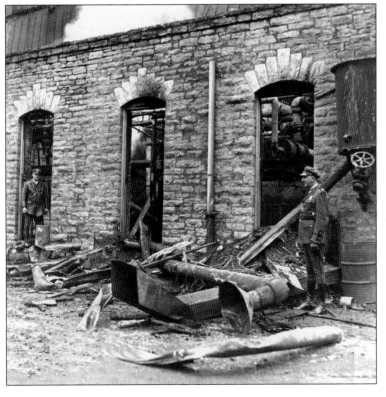

The Sisters of Charity survived a second fire on February 14, 1937. The kitchen and boiler room were heavily damaged, and the smokestack was almost completely destroyed. A temporary boiler was set up in the backyard so that the sisters could still use hot water during the building's reconstruction. The sisters continued to prosper: Just 10 years later, in 1947, they held a ground breaking ceremony for a new building, Mother Margaret Hall.

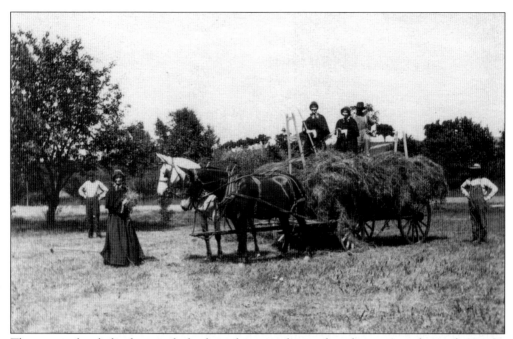

The sisters often helped out with the farm chores, such as picking berries or gathering hay, as Sr. Josephine (at bottom left) is doing in this photograph. They gathered their water from a hand-operated pump outside. Mail carrier Peter Bohner stopped by the motherhouse often. Bohner worked for the Mount St. Joseph post office for more than 25 years.

This is the 30-foot bell tower that sat on top of Mount St. Joseph. As shown in this photograph, it was taken down in 1978 for safety reasons. The motherhouse celebrated its 100th anniversary a few years later in 1984. The motherhouse has endured countless tragedies and afflictions, but the sisters have counteracted these events by continually making upgrades and improvements to the building, which is still fully functional.

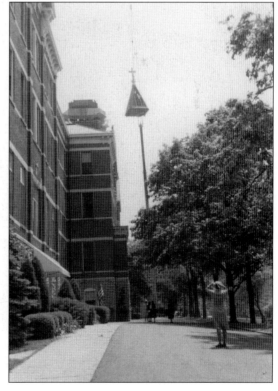

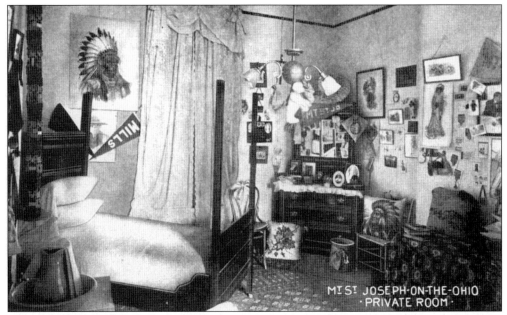

This 1925 postcard depicts a girl's private room at the old campus of the College of Mount St. Joseph. Those students not lucky enough to have their own rooms slept in dormitories that held about 12 students in each room. As seniors, students were allowed to use a larger recreation room to play games or study.

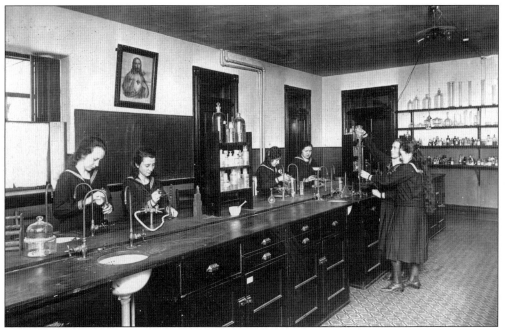

Mount St. Joseph Academy students work in the chemical laboratory in 1921. Pictured are, from left to right, Heloise Steiner, Monica Strange, ? Oblinger, Elvira Hansboraugh (who became Sr. Elvira), Gordon Smith, and Laura Grogan (who became Sr. Mary Alberta). The chemical lab was in room 106 in Marian Hall.

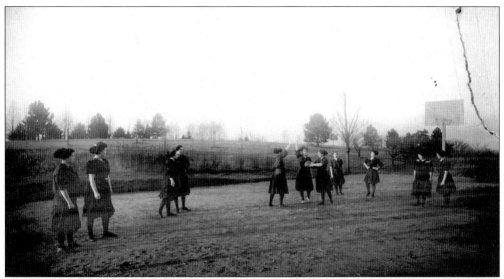

With the Delhi area's German heritage came a penchant for playing sports. This 1921 photograph shows girls from Mount St. Joseph Academy playing basketball on the courts near the school. Students of all ages were encouraged to play sports. A group of younger students from Mount St. Joseph Academy, called minims, often exercised in a playhouse on the property in the early decades of the 20th century, as seen in the cover photograph.

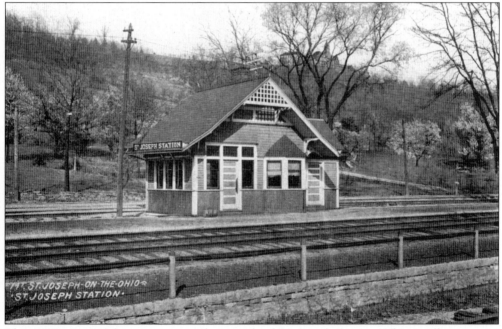

This 1908 postcard features a great photograph of St. Joseph Station. This small station sat just down the hill from Mount St. Joseph, alongside the present-day railroad tracks on River Road. To the right of the station are the steps that led up to the motherhouse. This station was completely under water during the 1937 flood.

The class photograph is of freshmen and sophomores at the College of Mount St. Joseph's old campus. It was taken the third week of October in 1921. The college opened in September 1920. These students have been identified as Barbara Thedick, Loretta Richards (who became Sr. Loretta Mildred), Mary Agnes Doorley, Dorothy Lane, Marie Urich, Mildred Hughes, Julia Shea (who became Sr. Marie Margaret), Abbie Sheam Marie Geoghegan (who became Sr. Barbara), Christine Rollman, Margaret Coleman, Alice Fye, Catherine Boesch, Sarah Evelyn Powell (who became Sr. Miriam Teresa), Mary Elizabeth Powell (who became Sr. Miriam Regina), Edith Barnhorst, two unidentified students, Anna Schaub, Anna Alice Frayne, Marion Mesorley (who became Sr. Ann Noreen), Louise Dunn, Mary Alice B., unidentified, Mary Alice Rhodes, Loretta Burke, Lea Mueller (who became Sr. Mary Lea), Ms. Heiler, Ms. Dunn, Marie Ankram, Madeline Burns (who became Sr. John Francis), Mary Malone, and Anne Pittman (who became Sr. Georgianna).

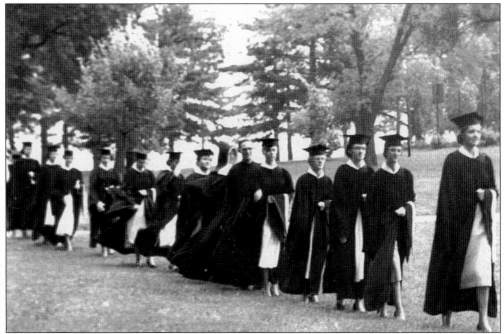

Mount St. Joseph was a girls-only college until the mid 1970s. In this 1958 graduation procession, however, the first male graduate is walking about halfway down the line. Brother Christopher Singler, C.F.P., attended the college and went on to become a Franciscan Brother of the Poor and to teach at Mount Alverno School. The college held classes at this old campus until 1962, when it moved to its present location.

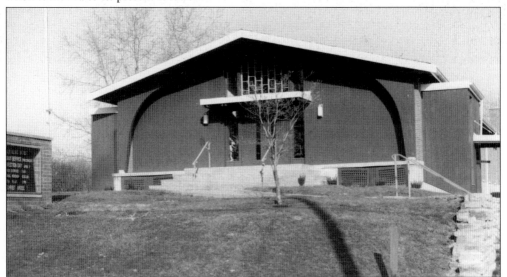

The Anderson Ferry Church of Christ gets its name from the congregation's original 1934 meeting place, the old Anderson Ferry School at River Road and Fenimore Street. The school building was condemned in 1941, so the parish held services in the Chambers-Hautman American Legion Hall. The 1960s brought the purchase of an adjoining lot at 376 Greenwell Avenue. The church that is used today was dedicated on October 23, 1966, and stands at 380 Greenwell Avenue.

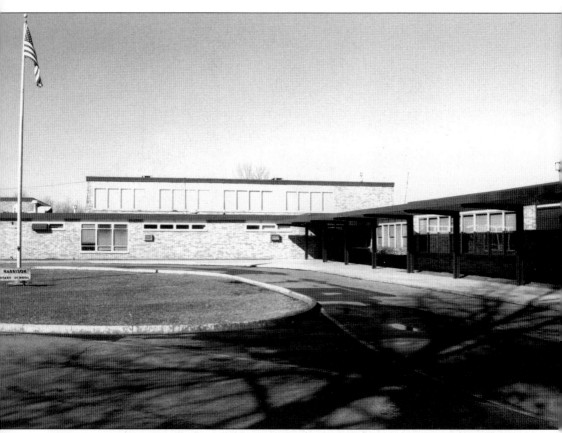

When enrollment grew too large for Delhi Elementary School to handle, Creed Oney Harrison helped the district plan a new school for western Delhi students. The school, built on Neeb Road to house kindergarten through sixth grade, officially opened in 1961. At that time, Delhi Elementary School became a junior high school. The new grade school was named C. O. Harrison School after Creed Oney Harrison, who was principal of Delhi Elementary School from 1931 to 1963. During Harrison's 32-year term, the faculty grew from 6 teachers to 31 and the Oak Hills School District was created. Harrison also organized and coached Sunday afternoon amateur baseball teams in his school district's area during World War II.

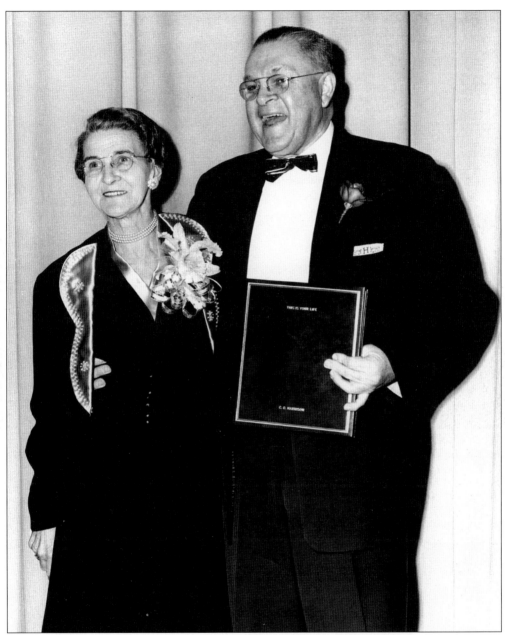

In this 1956 photograph of C. O. Harrison and his wife, Harrison is being honored in celebration of his silver jubilee of service to Delhi schools. His son, Lewis M. Harrison, followed in his footsteps when he became principal at Morgan Elementary School in Mount Adams. C. O. Harrison died in 1969, just 17 days before his 76th birthday. Born on September 12, 1893, on a 600-acre farm in Trinity, Kentucky, 10 miles east of Maysville, he was named after a Methodist circuit-riding minister in Kentucky named Creed Oney. He served with the Marines in World War I and returned to earn a bachelor's degree in education from the University of Kentucky and a master's degree from the University of Cincinnati. From 1926 to 1931, he was principal and coach at Mount Olivet School in Kentucky. He was appointed principal of Delhi Elementary School in 1931, five years after the consolidated school opened.

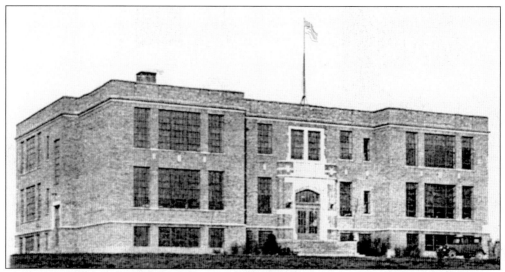

This is a photograph of the Delhi Township School, which opened in 1926 after the consolidation of three other district schools, Allen, Williams, and Northwestern. The consolidation forced the initiation of a bus service. This building, located on the corner of Anderson Ferry and Foley Roads, was built in the Gothic style that was common in the 1920s. Many additions were made to the school between 1932 and 1975. One addition was completed in 1956, adding eight classrooms, a primary playroom, a gymnasium, and locker rooms. In addition, the administrative offices were enlarged, the heating system was revamped, and an intercom was installed. Board of education supervisors, around 1926, included president L. F. Murphy, clerk Fred Juergens, and John and Henry Koester.

This grave marks the final resting place of Henry Darby. It is rumored that his ghost still haunts this small graveyard west of Mount St. Joseph, and some residents claim to see green lights glowing from the graveyard. Legend has it that Henry's ghost picks up his fiddle and plays all night, which has earned him the nickname of "fiddler of the greens." Henry Darby was an early settler in Delhi. He arrived here in 1818 and promptly bought 190 acres of land, on which he built a house and an inn.

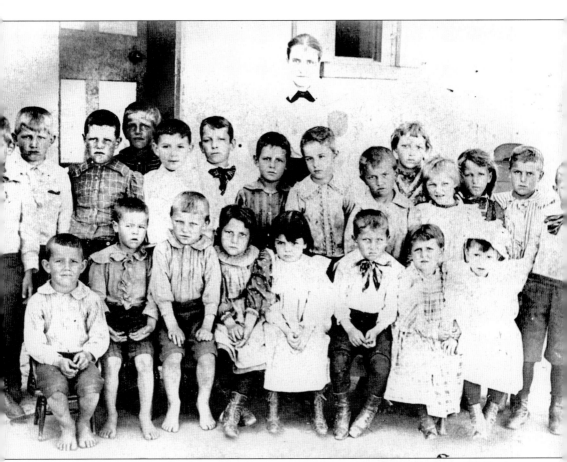

This photograph is of an early class of kindergarten students at the Williams Special School. It is interesting to note that many of the children do not have shoes, as some parents were not able to afford them. The Williams Special School was built in 1895 on one acre of land on Elm Street, 100 feet from Delhi Road east of Greenwell. It closed in 1926 when the district schools consolidated. The four lower grades had classes on the right (east) side of the building, and the four upper grades had classes on the left (west) side. The lower grades had a female teacher; a male teacher, who usually was also the principal, taught the upper grades.

Some local residents were buried in this burial ground, but it was mostly used for members of the first Baptist congregation in Delhi, which was founded on April 17, 1803. Founding members of the South Bend Baptist Church included Enos, David, Robert, and Chloe Terry; George and Rhoda Cullom; William and Amelia Worrel; and Ruth McLehany. The congregation met at a house located north of Rapid Run Road and east of Neeb Road, near the current site of the Delhi administration building. Rebecca Cottle Mayhew (1780–1817), often referred to as Betsy, was the earliest burial in this cemetery. She was buried in April 1817. Mayhew Road is named for Betsy's nephew, Zadok Mayhew, who was born in 1836. Zadok was a schoolteacher at the Williams Special School and lived in a house near the present-day Mayhew and Pedretti Roads. The Mayhew family was large; at one time, they owned all of the houses on Mayhew Road.

The Christian Restoration Association surveyed Cincinnati in 1927 and realized the need for a Church of Christ on the west side. The first evangelistic meeting was held in St. Paul's Evangelical Church on the first Sunday in December of 1927. The first minister was Brother Fred Smith, and William Howard Lowe and his wife opened up their home for early business meetings. The parish building and land were bought from St. Paul's Evangelical Church in September 1931 for $2,000. On October 28, 1951, the church's Bible school had a record 177 attendees. A new building for the Bible school was completed in May 1956. Today, the church continues to offer Bible school classes, youth group organizations, a ladies fellowship group, and vacation bible school.

The First Presbyterian Church of Delhi sits at 6558 Gracely Drive. The congregation was officially organized in 1831, but Sunday school lessons were offered here as early as 1829. The congregation reorganized on April 3, 1838, but there were still many topics on which it did not have a unified opinion, such as abolition and Civil War unrest. As a result, the church broke into two parts, the Old School and the New School. The group reunited 1866–1867, when a new church was built on land donated by Peter Zinn. The congregation disbanded in 2004, and the church, which was completed in 1884, sits vacant today.

This building at 1009 Overlook Avenue was originally used for members of the Elberon Country Club. When the club merged with Western Hills Country Club, the Third Church of Christian Scientists used this structure for worship. Today, approximately 150 members of the Victory Christian Center worship here. The congregation began meeting at the Delhi Community Center in November 1982 and is still served by its first minister, Terry Bear.

Four
PLACES TO SEE

The Delhi Historical Society became a formal organization on February 28, 1976. Founded by members of the Delhi American Bicentennial Commission, the group has published two books and has hosted annual Pioneer Days for more than 25 years. In 1989, developers Mike McCafferty and Joe Strotman donated the Witterstaetter farmhouse on Anderson Ferry Road to the historical society, which renovated the building for its headquarters and museum.

The Klawitter general store, seen here, was a landmark in Delhi for many years. The store sat on Neeb Road across from Our Lady of Victory church. Pictured in 1895 are, from left to right, Henry Remick, Kate Klawitter, Clara Miller Stew (being held), Teresa Miller Aylward, Anna Miller, Edward Klawitter, Joseph Klawitter, John Branhorst, and Herman Meister.

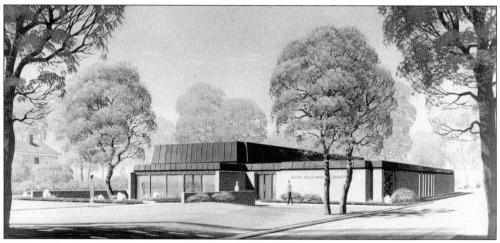

This is a drawing of the Delhi branch of the Cincinnati public library, which was dedicated in 1968. Its unique and accessible design won an award from the American Institute of Architects. The Delhi library, one of 38 branches of the Public Library of Cincinnati and Hamilton County, first opened inside the Delhi Township School on September 2, 1949. (Picture courtesy of the Public Library of Cincinnati and Hamilton County.)

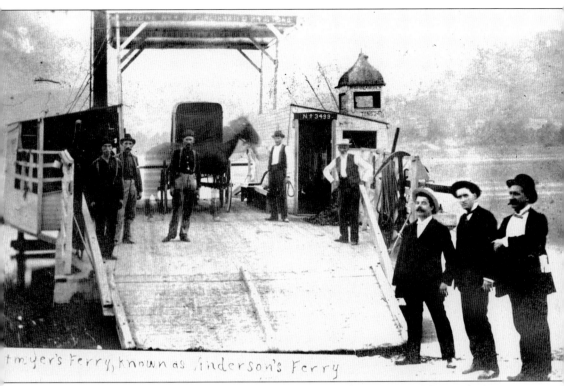

tmyer's Ferry, known as Anderson's Ferry

Anderson's Ferry has been used as an Ohio River crossing for centuries. Native American hunting parties regularly crossed the river to Constance, Kentucky, at this point east of South Bend. Traveling by ferry was hard before the lock and dam system was operational on the Ohio River. The water level sometimes fell to five feet, making ferry use unnecessary. And when the water rose to more than 80 feet (as in 1884 and 1937), the ferry workers must have had a day off. Raleigh Colston owned the first ferry, which he sold to George Anderson on August 30, 1817, for $351.87. The Anderson family controlled the ferry until 1841, during which time they also bought the landing on the Ohio side of the river from Alex McGraw. Charles Kottmyer bought the ferry in 1865 for a fee of $2,800, allegedly motivated by a doctor who told him to get an outside job. He dabbled in running a bus line, then purchased the Anderson Ferry Tavern, and, finally, bought the ferry itself.

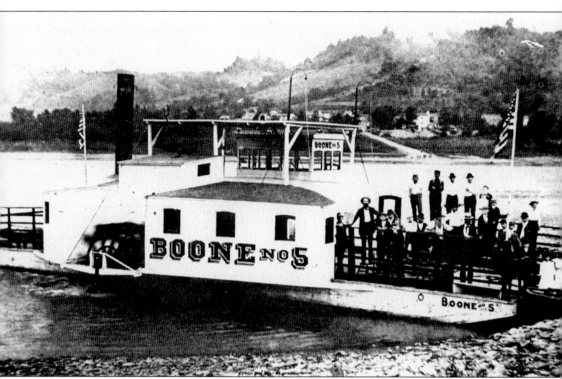

In the early decades of the 1800s, the ferry operated on power generated by horses walking on treadmills. The ferry was controlled by a wooden sweep on the back. Once, Charles Kottmyer leaned on the sweep too hard, broke it, and fell into the river. The Boone ferry ran over him, but he survived. In 1867, Kottmyer built a steamboat and named it *Boone No. 1*. Many Boones followed after. *Boone No. 2* was a night-owl, passenger-cabin ferry that carried only night workers—no horses. *Boone No. 4* was the first to use a rudder controlled by a small extension on top of the roof of the engine. *Boone No. 5*, the first Boone to have a full pilot house, sunk after hitting ice in 1918. In 1987, the Kottmyer family sold the ferry to Paul Anderson. Today, two ferries are in use, *Deborah A* and *Little Boone*.

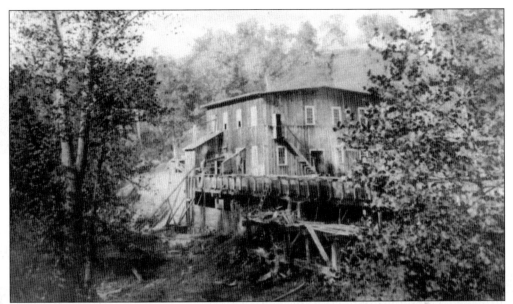

Kuehn's Mill, built in 1784 by Capt. James Findlay, stood at the intersection of Devil's Backbone and Muddy Creek Roads. The name was changed to Kuehn's Mill when Albert Kuehn took control; he ran the mill from 1850 to 1890. Kuehn enlarged the structure to operate as a gristmill that ran on steam power. Son Walter ran the mill from the time of his father's death until 1909, when Rev. Charles Thompson bought the mill and converted it to a poultry house. The mill was later abandoned, and it burned to the ground in the 1980s.

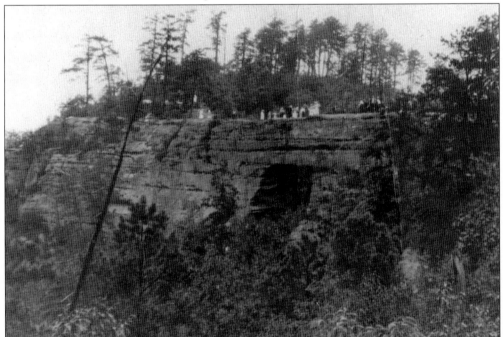

Devil's Backbone Road got its name from its many twists, turns, and hills. This photograph, taken on Easter in 1910, shows a 130-foot cliff, one of the many dangerous cliffs near Devil's Backbone and Muddy Creek Roads. Down in the valley, Muddy Creek Road can be seen.

Home to John Bens's blacksmith shop and Five Points Inn, this intersection was a local hot spot in the late 19th century. A small portion of Delhi Township along the river had been incorporated as a village in 1885, and the area was renamed Sayler Park when it was annexed to the city in 1912. Five Points Park, which is a Delhi Township park, is located where the inn and blacksmith shop stood.

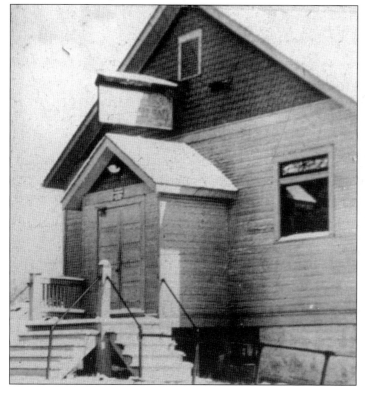

Over the years, this white frame building at Greenwell and Delhi Roads has served as a meeting place for a farmer's union, a mutual aid building, a church for St. Dominic's parish, and a tavern. The farmer's union that met here charged 50¢ for monthly dues. In return, farmers received health insurance that provided $5 per week in sick benefits if the insured fell ill.

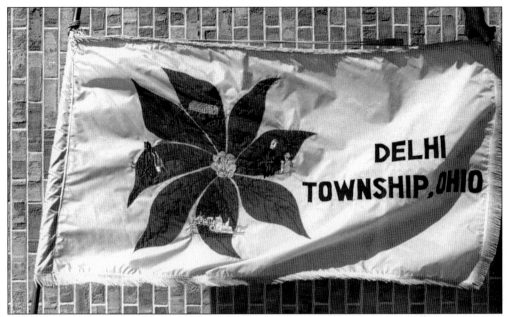

The Delhi Township flag is a large red poinsettia on a gold background. The leaves of the flower have four images on them representing four parts of Delhi's history. There is an image of a greenhouse to represent Delhi's many floral businesses, an image of a brother and a young boy to highlight the Mount Alverno School for boys, a representation of Anderson's Ferry, and a plow and a field to represent the early rural nature of the area.

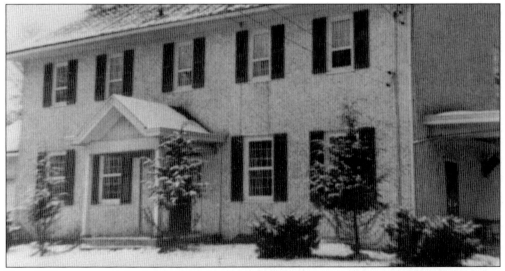

Peter Williams owned this land, which lay along Delhi Pike between Anderson Ferry and Mount Alverno Roads. In the 19th century, limestone vineyard walls dotted his land as well as other properties located on the hillsides overlooking Anderson Ferry Road and the Ohio River. Peter Williams spent 13 years (1807–1820) as a pioneer mail route agent for the government. His son William L., born on June 1, 1810, inherited the property when Peter died in 1837. William married a woman named Clarinda Applegate and built this two-story brick house for her and the couple's three sons, James A. (1840), Peter T. (1844), and George (1847). In later years, the property was used mainly as a dairy farm.

Patriarch Henry Darby (1781–1852) built this stone house in 1818. The Darby family lived and operated an inn here. The Darbys had plenty of opportunities to rub elbows with William Henry Harrison, who stopped by the inn frequently on trips from his North Bend home to Cincinnati. This house still stands at the intersection of River and Darby Roads.

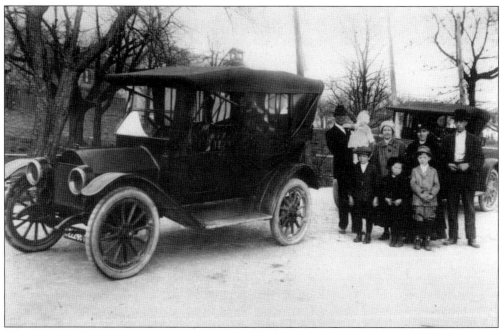

This c. 1919 photograph shows a family outing along River Road. The Darby house is in the background to the left. Pictured are, from left to right, the following: (first row) Frank, Bertha, and Carl Barth; (second row) James Lammers, Amy Barth, Dora Burkhard, and Agnes and William Barth.

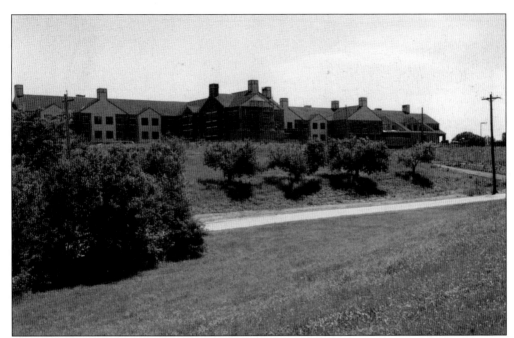

The construction of Bayley Place, the nursing home for the Sisters of Charity, started in early 1989. The first wing, including a new parking lot, was completed in September 1990. The building includes an activities room, a circular dining area, and a chapel featuring a tabernacle made by a Marianist brother in Dayton.

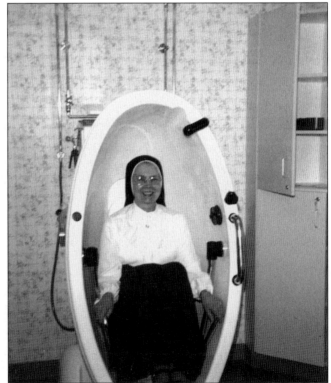

Here, Sr. Grace tries out an innovative bathtub for disabled or arthritic people. The sisters toured Bayley Place on August 5, 1990. About 1,000 people took the tour that day, including future patients and their families as well as many volunteers. The sisters provided snacks and drinks. The musical group The Variety Pak was on hand to play some songs for the first-time visitors.

The building at 988 Delhi Avenue is seen here on November 29, 1932. Notice the two children on the left, who seem to be staring at the photographer. Delhi Avenue, which is still a main artery through the township, used to be a pike on which travelers had to pay tolls. The money collected was used to help maintain the road.

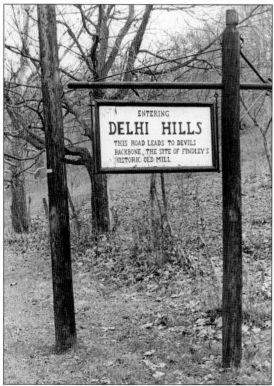

This old sign once stood on Cleves Warsaw Pike to welcome drivers to the Delhi Hills area. The sign, located on the boundary of the Delhi area, pointed out the historic significance of the area. The Delhi Hills Community Council erected the historical marker, but the sign disappeared around 1978.

This photograph of St. Joseph's cemetery was taken on April 16, 1943. Rapid Run Road runs along the left side, and Culvert Street, which runs parallel to Greenwell, is to the west. A few children seem to be playing in the center of the photograph.

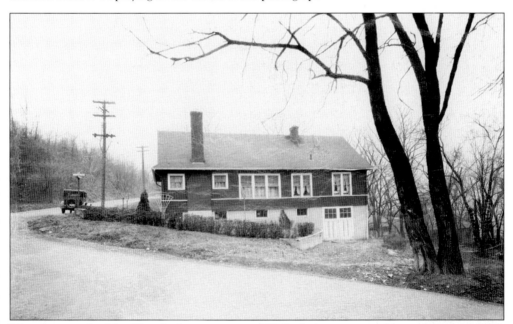

This photograph of the Chamberlain property at 8 Hillside Avenue was taken on January 4, 1934. Hillside Avenue intersects with Anderson Ferry Road, one of the main streets that runs through Delhi. Anderson Ferry Road dead-ends into River Road, another street that many Westsiders use. River Road was established in 1790 for better communication between North Bend and South Bend, and in 1793 the road was extended east from South Bend to Cincinnati.

This is a photograph of Hazel Currie, who was very involved in Delhi Township. She founded the Delhi Hills Community Council in 1941 and worked extensively with the Delhi Historical Society. She taught for 18 years in the Cincinnati public school system and volunteered many hours with the Girl Scouts. Currie also opened and oversaw the Hickory Hill day camp, a summer camp for children that she operated on her property. She lived on Pontius Road until her death from cancer in September 1978.

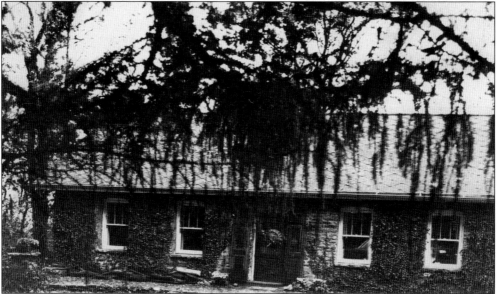

This house overlooking the river was built around 1860 and was owned by Annie B. Biegler. Her daughter Catherine Maria (1843–1908) married John Jacob Runck (1837–1922), and the couple moved into this house, which sits at the south end of Pontius Road. The Runck family sold the ivy-colored stone house to the Douglas Currie family in the 1930s. The house is on 30 acres of wooded land and has been recognized for historic preservation by the Miami Purchase Association.

Five
GREAT EVENTS

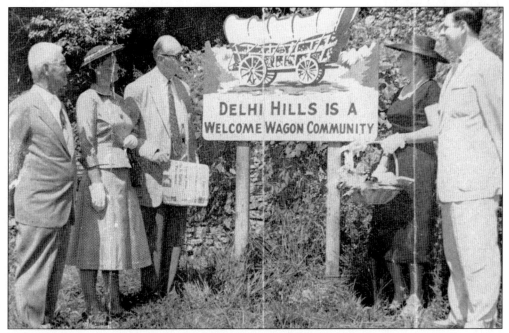

Delhi residents erected this marker by the historic old springhouse. The land was donated by Alfred Thomas, who is standing at the far left in this photograph. The president of the Delhi Welcome Wagon Club, Mrs. P. M. Terefenko, is standing to the right of Thomas. Also pictured are, from left to right, Cincinnati *Times-Star* circulation director Arthur Grossheim, Welcome Wagon hostess Betty Wiebold, and E. J. Dollreihs, a worker in the *Times-Star* promotion department.

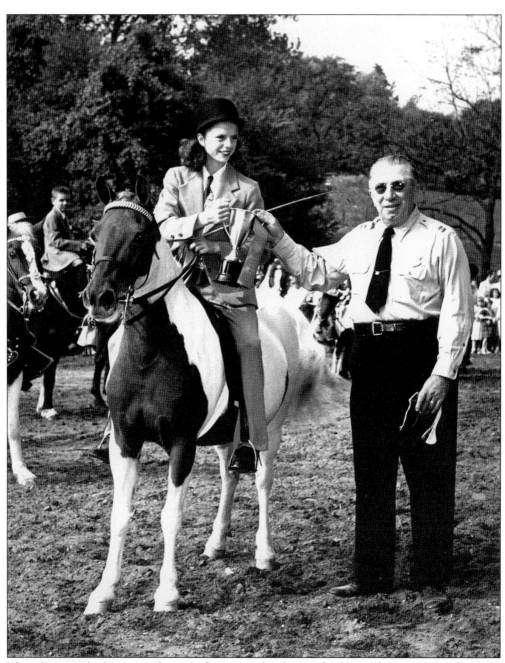

This photograph shows a judge awarding a trophy during the horse show at the Delhi Hills Community Fair. The Delhi Township Civic Club sponsored the first fair on October 17–19, 1941. The event, billed as "The Biggest Little Fair in the State of Ohio," boasted an attendance of 10,000. The Northwestern Foodclub 4H club did very well at local fairs. In 1921, the team won first place at the Carthage Fair Grounds, qualifying them to compete at that year's Ohio State Fair, where they won fifth place. Fairs remained popular until the 1950s.

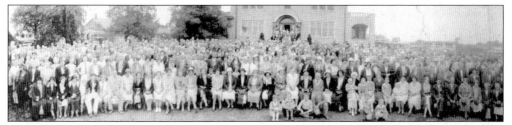

This photograph shows the attendees of the 23rd Annual Convention of the Vegetable Growers Association of America. The convention met in Delhi Township August 23–27, 1931, at the Seitz's home on Rapid Run Road near Pontius Road. Although many of the florists are gone, the area does still have some green spaces, such as the Embshoff Woods and Nature Preserve, the Joseph M. Bruening Park, and the Delhi Township Park.

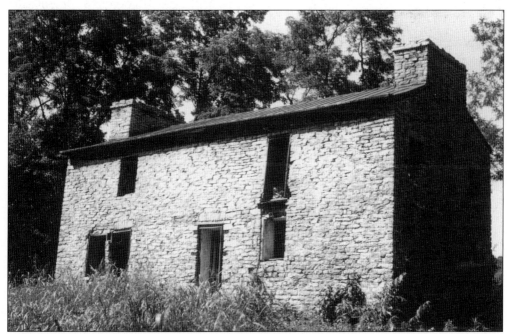

This stone house is approximately 200 years old and still sits in Constance, Kentucky, overlooking the Ohio River. Barney Dolerhie was the first owner. The house was then used as a grocery store. Later, Fred Zimmer moved to the area, bought the property, and converted the "Old Stone House" into a tavern that served buckets of beer, lunch, and whisky—often charging just a nickel for a tumbler of liquor. In 1870, Charles Kottmyer bought the house. It is deserted now.

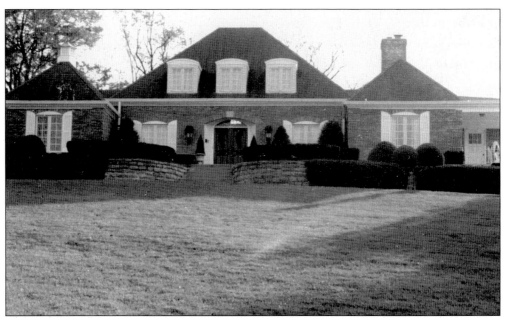

In 1964, Homerama chose Delhi to showcase its beautiful and extravagant homes. Homerama was developed on 200 acres of the Steven Elsaesser dairy farm. This is the front view of a house on Palisades Drive that overlooks the river. The house includes such luxurious amenities as a swimming pool with pool house and a tennis court. Many other houses in the area showcase tennis courts, pools, and large parcels of land.

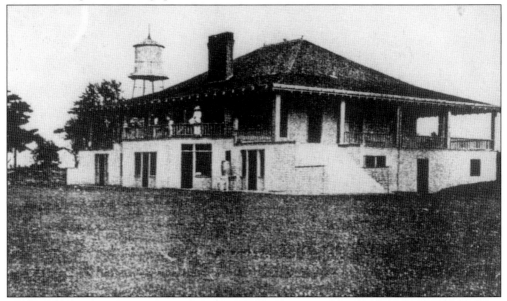

This 1909 photograph shows the clubhouse of the Elberon Country Club from the rear. The Indian Mound is visible on the left. The country club was built on 30 acres near Rapid Run and Overlook Roads. The property was offered for purchase to members of the club, but the price was too high. On August 28, 1912, the club changed its name to Western Hills Country Club in an effort to appeal to residents of other suburbs, such as Price Hill and Westwood. With the name change came a move to the Short family farm on Cleves-Warsaw and Neeb Roads.

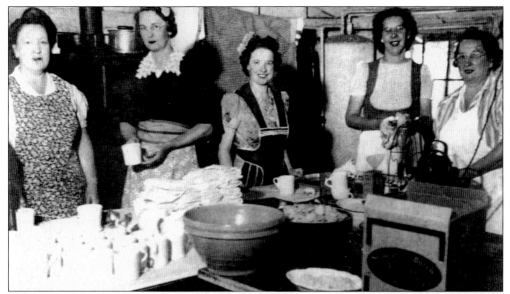

At the corner of Anderson Ferry Road and Romance Lane lay Green's Woods picnic grove. This popular spot was the setting of many church and school outings. Charles and Martha Green owned the grove in the 1820s. Their 90 acres of farmland encompassed an area along Anderson Ferry Road between Foley and Delhi Roads. Pictured here in the kitchen are, from left to right, Mrs. Ray Keis, Mrs. Charles Lippleman, Mrs. Elmer Bruemmer, Mrs. Oscar Feist, and Mrs. George Kortgardner.

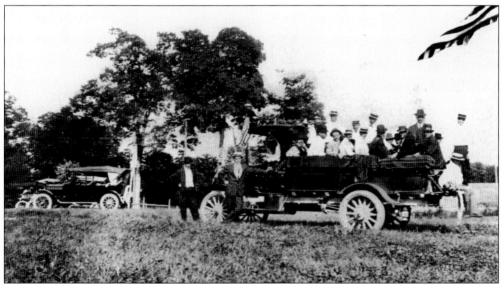

Charles Lauterbach was born in 1872 and grew up to become the owner of the Lauterbach Picnic Grove around 1905. In his spare time, he was a bricklayer and a builder. The grove was on the corner of Delhi and Greenwell Roads, where a United Dairy Farmer store sits today. In the grove's heyday, it encompassed 10 acres and attracted local Delhi residents as well as kids from other neighborhoods. Neighbors with trucks like the one seen here often shuttled people to the grove. Busses also picked people up from West Eighth Street and Pedretti Road and dropped them off at the park.

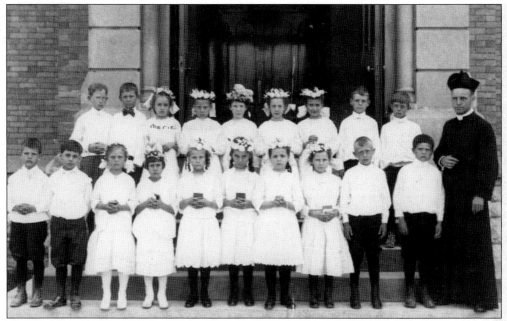

This photograph shows Marie Ohmer at her first communion at Our Lady of Victory. Someone in the Ohmer family printed Marie's name on the photograph to identify her. Notice that all of the children are wearing white dresses or white shirts. The sacrament of first communion, which used to be celebrated by children who were at least 14, is now given to younger Catholics.

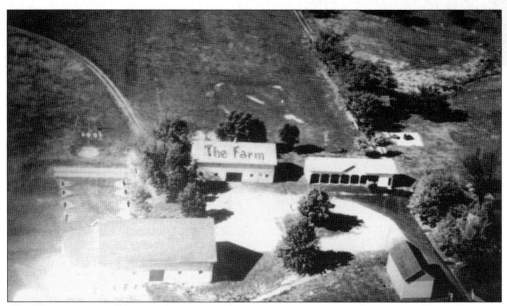

The Elsaessers are well known for owning The Farm. Part meeting room, part wedding reception hall, The Farm has been home to many family-style dinners and parties over the years. One of Herman and Petronella's sons, Steven, was blinded by medicine used to cure his pneumonia, and later in life he became deaf as well. But he had a strong will and he wanted to farm, so he purchased a dairy farm. Steven's brother William eventually bought this land from Steven's widow, and he built a party hall and ran a catering business here.

This photograph shows all of the Elseasser brothers. Pictured are, from left to right, the following: (first row) Steven, Anthony, and William; (second row) Al, Joseph, and Frank. Father Herman Elsaesser came to Cincinnati in the late 1800s and worked at a bakery on Sixth and Central Streets. He fell in love with fellow bakery employee, Petronella, and they married on July 15, 1890. They had 10 children: Katie, Tony, Al, Frank, Anne, Teresa, Joe, Marie, Steve, and Bill. Around the beginning of the 20th century, the family built a large house on Rosemont Avenue. They later donated part of the land to build St. William's Church. Tony, Al, and Frank, built houses on St. William Avenue. The youngest three girls, Anne, Teresa, and Marie, became nuns. Katie married Lee Kremble, and the couple moved to Sunset Avenue. Herman died in 1935 at the age of 72. Petronella passed away in 1941.

Fred H. Schroder (1887–1978) owned property on a 212-acre farm on Anderson Ferry Road that was given to him by his father-in-law, John Henry Hehe. Schroder built this grape arbor addition adjacent to the house. Schroder also built the barn that is currently The Farm, a party hall owned by the Elsaesser family. The original barn was completely destroyed by fire in 1917, but was rebuilt exactly as before. Since Hehe had so much pasture area, he rented space for city horses that had to spend time in a pasture to cure sore feet caused by harsh city streets. At Hehe's death in 1928, Schroder and his brother-in-law William Braun were forced to sell the land to speculators Ferdinand and Fred Bosken, who campaigned for the Cincinnati airport to be built in its place. The land was sold to Steve Elsaesser instead.

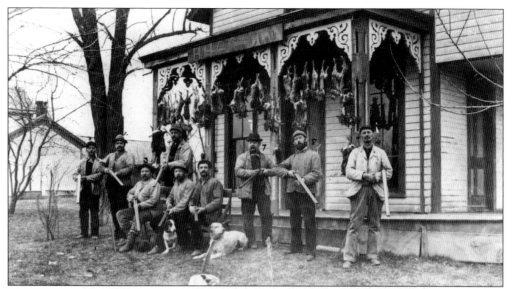

The Here He Goes Gun Club met on Foley Road to talk and to hunt. Members included John Ludwig, Anthony Blistain, Christ Becker, August J. Muth, Charles Abaecherli, John Burg, August Ritzer, George Hartke, and Edward Story. The group's hunting grounds were on Blue River Farm in Indiana.

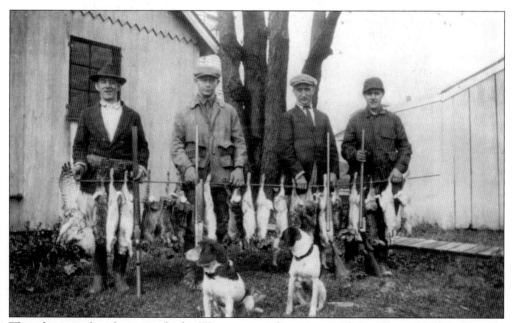

This photograph, taken outside the Witterstaetter house on Anderson Ferry Road in the early 1930s, shows a group of friends and relatives on the opening day of hunting season. Pictured are, from left to right, Charles Witterstaetter, Art Broxterman, Fred Klein, and Joe Witterstaetter.

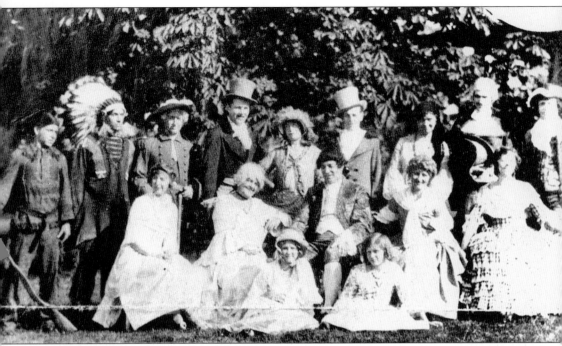

This is part of an elaborate celebration held in June 1931 for the dedication of Foley Road. These actors performed the historical play *The Trail* by Emma Backus. Backus was a well-known Cincinnati author who bought the Myer schoolhouse in 1926 for use as a quiet writing sanctuary. She formed the Delhi Arts Guild in the late 1920s and the Delhi History Club around 1930. Both clubs were open to men and women and included many of Backus's friends and neighbors. Backus later converted the Myer schoolhouse to a community center to be used for parties or meetings as well as for cultural events such as musicals, dramas, and literary readings. Backus was chairperson of the Ohio division of the George Rogers Clark Memorial Commission of Ohio, and, along with Hazel Currie, she founded the Delhi Hills Community Council in 1929. She also volunteered for the Civic League Women's City Club, the MacDowell Society, and the Historical and Philosophical Society of Ohio.

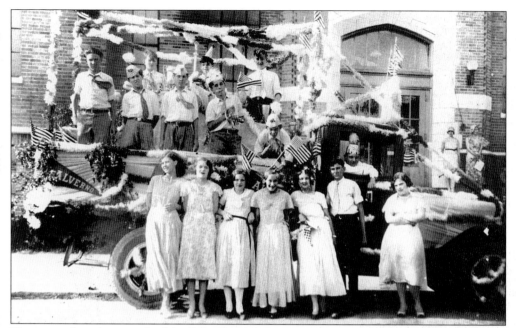

This is another photograph of the Foley Road dedication on June 6, 1931. The boys standing in the truck are all students of Mount Alverno, and Brother Ruddy is sitting in the cab of the truck. The girls in the photograph are, from left to right, Mae Murphy, Cecielia Scherer, Jean Lame, Marion Schroeder, Evelyn Witterstaetter, and Rosella Deller.

This program shows that there were quite a few amateur actors among the Delhi families. Emma Backus wrote most of the area's plays, so it is likely that she had a hand in this one. A true artist, she worked on the pageant A Bowl of Promise, a 1974 novel titled The Rose of Roses, and a c. 1909 operetta titled Twilight Alley. Backus was also involved in many local clubs and organizations, such as the Delhi Hills Community Council and the Civic League of Women's City Club.

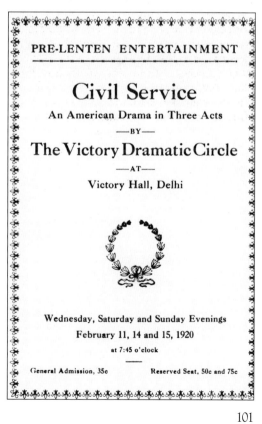

When the Myers School District No. 3 closed, the schoolhouse went up for auction. The day of the auction, Henry and Emma Backus happened to drive past the event while out for a relaxing afternoon drive. The couple put in a bid for the one-room schoolhouse, and it was accepted. In 1928, they built a three-room addition on the rear of the school, where their son, Harry, lived with his family after his marriage in 1936. The schoolhouse property was sold in 1986 to Charles and Pauline Johnson for $107,000. In 1990, the Johnsons sold their property, and Harry Backus sold his additional plots of land to the Sisters of Charity.

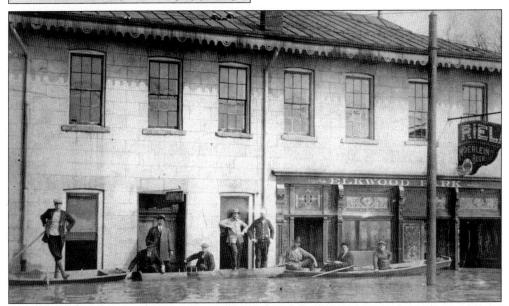

In 1913, the Ohio River flooded the lower Delhi area. In 1937, an even more devastating flood hit. Most of Cincinnati was without water because the water pumping station was under water, so many people came to the Delhi Springhouse on Delhi Road to get fresh drinking water. Other natural disasters have befallen the area: Tornadoes struck on July 7, 1915, and April 4, 1974, the former killing one person in Delhi and several in West Price Hill along West Eighth Street. Hardest hit were Delhi, Greenwell, and Mayhew Avenues.

Six
DELHI NEIGHBORS

This is a great view of the Martini house on Martini Road, built by Patriarch Phillip Martini in 1880. Both Magdalena and Phillip Martini lived long, full lives: Magdalena was 83 when she died on February 8, 1923, and Phillip was 92 when he passed away on April 11, 1925. The house still stands today and is still owned by members of the Martini family.

Phillip and Magdalena Martini are pictured here. Philip was born September 24, 1832, and came to America in 1850 with his father, Jean, and brother John. They left Jean's wife, Anne, and six children behind in Lorraine, France. Jean returned to Lorraine in 1852, while John and Phillip stayed in America. Phillip continued to work for Peter Strassel, the man who paid his way to America. Working for $2 a week, Phillip managed to pay Strassel back. He married Magdalena Kleem in 1858, and the couple had 12 children: Mary, Ann, Rosa, William, Elizabeth Sandman, Charles, John, Clara Reimerink-Essen, Catherine, Louise, Joseph, and Andrew. Son Charles married Eva Schwartz, who was born and raised on Martini Road. Phillip grew sweet potatoes, strawberries, grain, and grapes for making wine. Ray Martini (1905–1985), son of Charles, remembered going sleigh riding on Neeb Road at Five Points with his friends from Our Lady of Victory: Mike and Al Backscheider; Henry, Adolph, and Joe Schill; and Tony Heintz.

Henry Bloemker and his wife, Sophia Eikhold, traveled to America together from Prussia in 1855. They settled in Delhi with their children, William, Frederic, Charles, and Benjamin. Henry bought this 22-acre farm on Anderson Ferry Road south of Foley Road. Eventually, he also bought the adjoining 23-acre lot, previously owned by the H. Buckleman family, where son William and his wife, Emma Huenefeld, lived out their days. Frederic was a milk wagon driver in the late 1880s. Charles and Benjamin married into the Koester family.

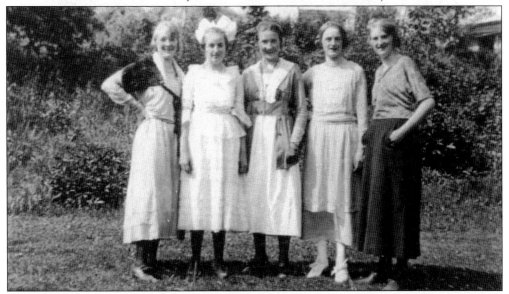

Magdalena "Anna" Reitman married Wendelin Ohmer on November 6, 1888, and had 11 children. Here, five of her daughters are, from left to right, Helen, Marie, Barbara, Katherine, and Theresa. Wendelin Ohmer was born on April 20, 1867, to Michael and Barbara Heitzman Ohmer of Connersville, Indiana. Wendelin died in 1930, and Anna passed away in 1948.

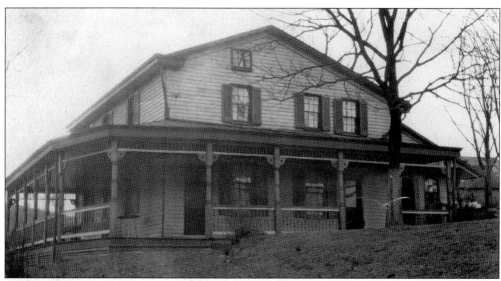

In 1906, Wendelin and Magdalena Ohmer moved from Clifton to this 10-acre plot of land located north of Rapid Run Road and just east of Neeb Road. Sons Wendel, John, Charles, and Jake helped establish the Delhi Volunteer Fire Department in 1935. Charles married Clara K. Willig in 1919, and they settled on Rapid Run Road just west of Neeb Road. The house was razed in the 1980s. Their farmland is now the Stonebridge subdivision. Charles and Clara had seven children: Anthony, Clara, Raymond, Norbert, Donald, Eileen, and Elmer.

Before Charles Stadtmiller moved into this house at 192 Pedretti Road, Severin and Rose Fichter Leon lived there. When the house was first built, there were two rooms upstairs and two rooms downstairs; additions were made in later years. In 1954, the property was sold to the Delhi Swim Club. The house was demolished in 1994.

Henry Sedam, born in September of 1782 or 1783 in New Jersey, was a son of the founding father of Sedamsville. He married Elizabeth Engle, and they had 11 children while living in Indiana. Henry's parents, Cornelius and Elizabeth, spent most of their lives in present-day Sedamsville. They had five children. The Sedams were of Dutch descent, and the family name may have originally been spelled Suydam. Cornelius served in the Revolutionary War. He retired to an area near Bold Face Creek. He died in 1823, willing most of his land and his job in the legal system to his son Henry. Henry was a laid-back judge who was very different from his strict, military-oriented father. Henry often handed down creative sentences: Those found guilty might have found themselves banished to Kentucky or to a wine cellar.

Reese Evans Price was born in Wales. In 1807, he moved to a hilltop above Cincinnati that would later be named after him: Price's Hill. He married Sarah Matson and served as a Delhi Township trustee in 1858. He was also known to be somewhat of a recluse. He abstained from liquor, tea, coffee, tobacco, and even apples, the forbidden fruit of Eden. Bishop A. Morris wrote this of Reese in the Christian Advocate in 1849: "Upon the whole, [he] is the most pleasantly deranged man with whom I am acquainted."

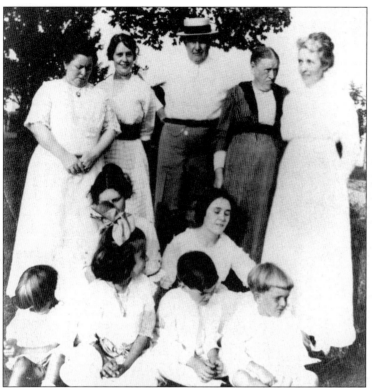

This photograph of the Wolter family was taken in 1913 or 1914. From left to right, in the third row, are Mary Wolter, Olga Huelsman Wolter, and Henry Wolter Sr. Next to Henry is an unidentified member of the Harpeneau family. Olga's mother stands on the end. It is believed that two of Olga's sisters are sitting in the middle. The children in the front row are, from left to right, Katherine, May, Henry, and Charles. Katherine married into the Wheeler family, and Mary married into the Ostendorf family.

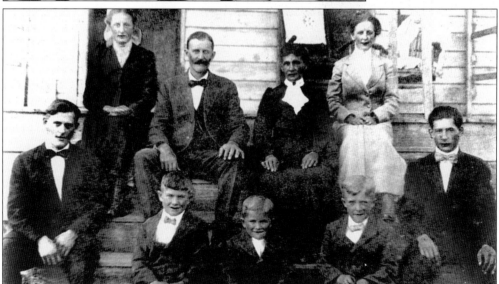

This photograph of the Wolfer family was taken in 1920. Pictured are, from left to right, the following: (first row) Clemens, William, John, Herbert, and George; (second row) Anna, Jacob, Rose Broxterman Wolfer, and Marina. Michael Wolfer's sons Anthony, Frank J., and George M. inherited their father's lands in Anderson Township, and George F. and William Jacob split the Delhi acreage. George F. sold his lands to the Lipps family, sometime between 1889 and 1914, and William continued the Wolfer name in Delhi. He married Rose C. Broxterman on June 25, 1890, and the couple had seven children. Even today, many Wolfers live in both Delhi and Anderson townships.

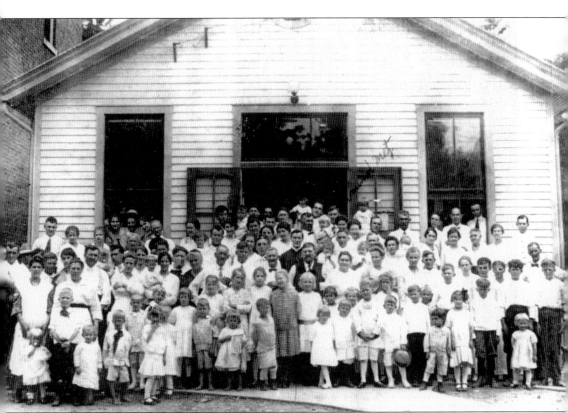

The Wolfer family was extensive, as is clear in this 1915 photograph taken outside of the old Guardian Angel church. Michael Wolfer was born in Germany on October 12, 1820, and had a rough trip to the United States: His boat wrecked, leaving him desolate in New Orleans. He stayed there for almost a month, working odd jobs so that he could travel to the Queen City. Once here, he had luck finding work as a butcher, a job that he had trained for in Germany. On February 24, 1846, he married 17-year-old Barbara Oehler, whose father, Simon, had to sign his consent. Michael prospered as a butcher, and on July 19, 1859, he moved his family to a 21-acre farm on the east side of Neeb and Delhi Roads. Michael bought 33 more acres to add to his property, as well as 200 acres in Anderson Township.

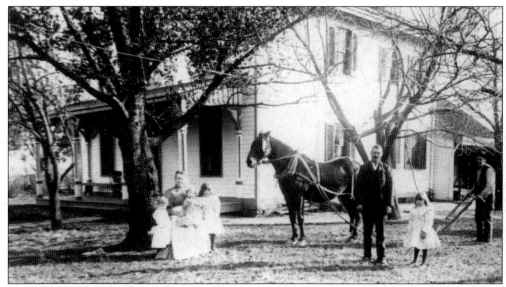

This photograph of John Story and his family was probably taken c. 1865, when John and wife Mary Ann Koerner had just moved to their house on Cleves Warsaw and Ebenezer Roads. Pictured are, from left to right, Dorothea M. Spiess, grandmother Emma Sarah Story, Amelia Meyer, Ella Shaw, William C. Story, Edna M. Story, and grandfather John Story. The estate was passed to John's son William, who in turn passed it down to his six children. In 1985, the property was sold to BKS Investments, which turned it into Western Hill Retirement Village and Concord Village Shopping Center.

The Story family starts with patriarch Yost Story (1790–1869), who came to America as a widower in 1831. He moved his family to the 130-acre farm of John Shaw on Rapid Run Road in 1838. Yost's son Jacob, born in 1818, became a successful gardener in Riverside. His home eventually became the St. Vincent de Paul rectory. Son Peter, born in 1822, and second wife Apolonia lived with Yost. For Apolonia's care of Yost in his later years, he left her the sum of $700, while Peter received 50 acres of land. Yost's great-grandson Charles A. Murphy became a prosperous gardener like Jacob and operated a greenhouse on the Rapid Run Road land in the early 20th century.

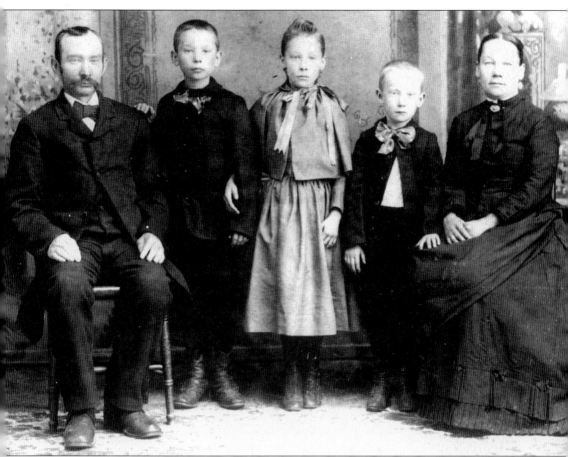

This c. 1890 photograph of the Lipps family, from left to right, shows Bernard Sr., Bernard Jr., Elizabeth, Andrew, and Guenegundis (Kleinhaus). Bernard Lipps Sr.'s grandfather, Gregory, came to Delhi in 1831. He brought at least seven children with him to the United States. He later moved to North Vernon, Indiana, but he returned to Delhi in 1845. Gregory bought a 27-acre farm from Louis Rennert between Bender Road and Old Delhi Pike. His son Andrew inherited much of Gregory's lands upon his death in 1859 or 1860. Andrew married Catherine Grebner and had eight children, one of whom was Bernard, born in 1854. Bernard's brothers, Henry (1866–1952) and Andrew (1861–1947), lived with their families in eastern Delhi near Pedretti and Mount Alverno Roads. Descendant Joseph L. Lipps often offered transportation to local residents. He would drive his large truck from his house on Delhi and Neeb Roads, pick up his neighbors, and take them to picnics or other fun places.

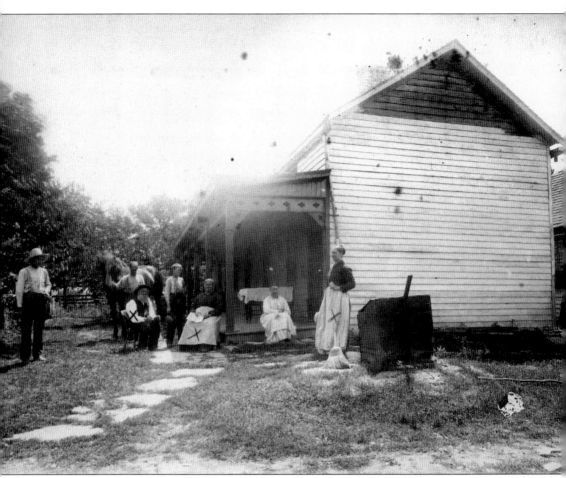

Joseph Gies raised his family on this 20-acre farm. This photograph was taken in 1840, when the address was Box 21 Plank Road; it is now 5575 Cleves Warsaw Road. The Gies family immigrated to the United States from Alsace-Loraine. Joseph married Cecilia Dinah Weiermann on February 7, 1900. They raised Cecilia Anna Gies (born March 12, 1902) and her three younger siblings, Mary, Joseph, and Frances, at this home. Joseph spent much of his time working with the Democratic Party in Delhi, which was known than as the Roosevelt Democratic Club. He was the club's presiding judge, and when he died on July 15, 1928, his daughter Cecilia took his old position. The meetings were held in Klawitter's Hall. The Gies family also used Klawitter's to park their horses on rainy Sundays that they spent at Our Lady of Victory Church.

The uncommonly high quality of Delhi's land was highlighted when Nicholas Longworth, a wealthy Cincinnati landowner, advised Delhi landowners to grow grapes for winemaking. The produce turned out to be excellent. Perhaps winemaking in the area would have prospered if not for a blight that rotted all of the vineyards in 1856–1857.

George Kortgardner Sr. purchased this brick farmhouse, which was located on 40 acres of land on Anderson Ferry Road halfway between Foley and Delhi Roads, sometime around the turn of the 20th century. It remained in quiet suburbia for years. The house was razed for a subdivision in the 1990s.

Frank Koch was born in Alfhausen, Germany, in September 1834. He married Elizabeth Landwehr, who was born on January 18, 1834. The couple moved to the United States on September 10, 1875, arriving in Baltimore, Maryland. Henry George, their only son, was born in March 1887 in West Virginia. The family came to Delhi years later.

Henry George Koch married Anna Rose Wohlfrom, who was born on December 6, 1881. The couple had 11 children: Frank, Elizabeth, Anna, Marie, Harry, Joseph, Clara B., Helen Rose, Edna A., Aloysius, and Arthur J. Elizabeth married August Gus Robben, and Anna married Simon J. Binder. Frank died on July 2, 1910; Elizabeth had died a few years earlier on April 29, 1908.

John Cleves Short went to school at Princeton and became a lawyer in the office of Judge Burnet in Cincinnati. He was also an aide-de-camp to Gen. William Henry Harrison during the War of 1812. Short married one of Harrison's daughters, Betsey Bassett Harrison, but she died early in 1846. Three years later, he married Mary Ann Mitchell. John Short died on March 3, 1864, of a heart ailment, and Mary Ann passed away in 1871.

This photograph shows Charles Martin Ihle hugging his wife, Magdalene Buechle, on their farm on Mount Alverno Road, Section 10. Charles and Magdalene belonged to Our Lady of Victory in 1870. They later helped form a new Catholic parish, the Sacred Heart Church. Charles's father, Karl, donated one of the three bells on top of the church. Sacred Heart was completed in 1891; unfortunately, it burned to the ground in 1906. The Ihle family then attended masses at Our Lady of Perpetual Help in Sedamsville. Magdalene died early in 1918, and Charles raised their three daughters and five sons: Mary, Emma, Catherine, Carl, Bernard, Joseph, Frank, and Albert M. Charles died on July 27, 1955.

Herman Duhme, Jacob Strader, and Stepheen S. L'Hommedieu all made their mark on Cincinnati. Duhme, pictured here, settled near the college of Mount St. Joseph and spent his days as owner of one of the largest jewelry stores in the west. He traveled daily to his store at Fourth and Walnut Streets in downtown Cincinnati. In 1816, Strader moved to Riverside, right down the street from L'Hommedieu, and in 1822 was named captain of the steamboat *General Pike*. He was a steamboat guru for 30 years, during which he built 23 boats that significantly advanced steamboat technology. L'Hommedieu settled near Sedamsville and was president of the Cincinnati, Hamilton, and Dayton Railroad from 1848 to 1870.

This late 1800s photograph shows the family of Mathew and Mary Hemann Mangold. Pictured are, from left to right, the following: (first row) Anthony, Mathew, Agnes, and Mathew Jr.;(second row) Edward, Annie, Minnie, Laura, Mamie, Mary, and Josephine.

John Oehler was born in 1823, the son of Andrew Oehler. He had two brothers, Andrew Jr. and Simon. Andrew Sr. owned a plot of land near Covedale, Foley, Pedretti, and Rapid Run Roads that he bought from John Terry in the 1830s. His three sons each received an equal share of the land upon his death. John Oehler married Julia Tranley in the 1840s and had three children, Charles Oehler, Barbara Oehler Lienert, and Julia Oehler Doll. John died in 1889.

Peter Zinn was born in 1819. At age 18, he was a journeyman printer, and he later worked as a reporter for the *Daily Times*. He served as a major in the army during the Civil War and was a leader in the defense of Cincinnati when there was fear of a Confederate attack. He became a lawyer and worked hard to improve the area below Mount Alverno Road near Riverside. The year before he died, he planted 1,000 trees along River Road. He died at home on November 17, 1880.

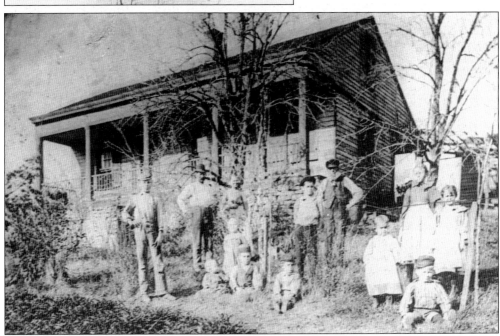

This is a photograph of the Peter Henseler family in front of their house. Pictured are Oscar, Peter, Barbara, Marie, Camilla, Cyril, Linus, Clem, John, Pauline, Esmerelda, Zinona, and Lester, who is sitting on the ground. Other Delhi pioneers included Nathan and Nancy Allen and Sarah and Henry Applegate.

Emma Hautman Diss was born in 1863 in Avondale. She married Francis Xavier Hautman in 1885 in St. Aloysius Church. The couple had nine children and lived in a house at 132 Meridian Street. Francis was born in 1859 and spent his days as a wagon maker. He died in 1926; Emma died in 1953.

This house on the northeast corner of Pedretti and Mayhew Roads was built in the 1820s. George Augusta and Lizetta Orlemann bought the 15-acre property from an Italian man, Peter Sivori, in 1918. An old garage on the edge of the property, which cannot be seen in this photograph, was originally used as a hay barn. The barn was known to have hand-hewn, hickory-pegged beams.

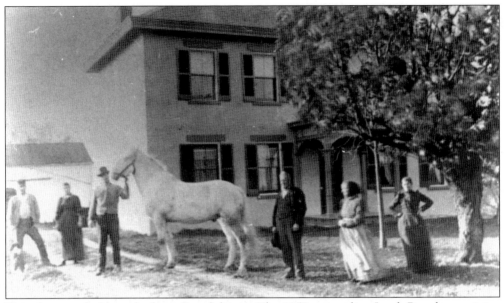

This photograph shows the large Runck house. The 1850 census lists Jacob Runck as arriving in 1805. He was followed by another Jacob in 1810, Henry in 1812, and Frederick in 1824. It is because of Henry's land donation that the Runck schoolhouse was built and named after him in the late 1840s. Delhi history shows there are four Jake Runcks, all with different nicknames: Big Jake (the patriarch of this family), Little Jake (his son), Black Jake (because of the color of his beard), and Red Jake (because of the color of his hair and moustache).

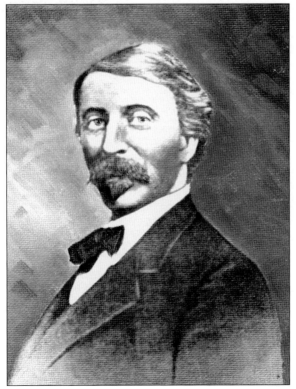

Francis Pedretti was born in Chaivenna, Italy. In his 20s, frustrated by the lack of liberty in Europe, he moved to America and started working as an artist. In 1854, he moved to Cincinnati with his wife, Catherine Maitland, and they bought 11 acres of land on the corner of Foley and Pedretti Roads. They had three children, Raphael, Charles, and Eugenia. The two sons studied art in Milan, then returned to Cincinnati to open and run an art business with their father called Francis Pedretti & Sons. Francis retired at age 62, but his sons continued to run the business until 1905.

This is the 17-room Rentz home on Foley Road. Before settling in the area, Sebastian Rentz was a servant to a wealthy family in the early decades of the 19th century. He traveled with them to the United States in 1825 and opened a bakery in Cincinnati. He married Cecilla Zoller in 1828. The couple purchased 40 acres of farmland in Delhi for $1,900 to plant grape vineyards. In 1846, Rentz won the Longworth Cup for the best Catawba wine. Sebastian died in 1866 and Cecilla earned extra money after Sebastian's death by renting out apartments in the city. When she died in 1889, the estate was valued at $250,000. The 110 acres were divided among the six children.

Daniel Gano (1794–1873) was an early settler in the western most section of Delhi Township. He attended Brown University at age 13, and stories have been told of how he rode 1,100 miles on horseback to get there. He also studied at Transylvania University in Lexington, Kentucky, and practiced medicine for a short time thereafter. He loved to garden, and he was the first chairman of the first Society of Agriculture in 1827. He was instrumental in building the Miami Canal, and he devoted his time and resources to liberating at least three slave families. He owned many farms in the present-day Sayler Park area and raised racing horses on his property. One farm that stood along present-day Gracely Drive included a Native American mound, which spectators would climb to get a better view of the horse races.

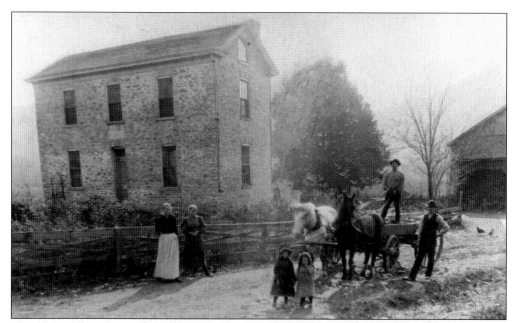

This photograph shows the Yunker house on Cleves Warsaw Pike at the foot of Van Blaricum Road. The stone above the door indicates that the house was built in 1873. Outside the house stand various members of the Yunker household. Benedict Yunker was an early Delhi pioneer: Records show that he was living in Delhi as early as 1856 with his wife, Theresa Lipps Yunker. A high-water mark on the barn shows the peak of the flood of February 14, 1884. The 1937 flood reportedly reached the first floor.

This wedding photograph is of Amelia and Fred Hilgemeyer. Amelia Lang Hilgemeyer was born in Ohio, but her husband, Fred, was a native of Germany. The couple had four children: Lizzie in 1892, Anna in 1893, Fred in 1895, and Ida in 1897. Mrs. Charles Waldack, a well-known photographer of that era, took this photograph. Her studio was downtown on the southwest corner of Liberty and Vine.

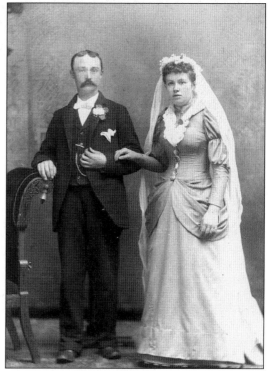

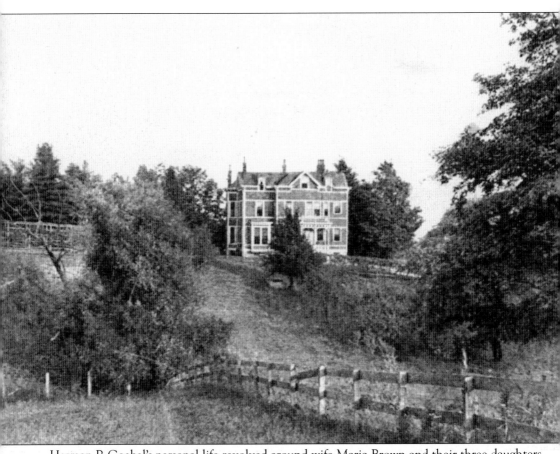

Herman P. Goebel's personal life revolved around wife Maria Brown and their three daughters. The family lived in this house on Rapid Run Road in the 1880s and 1890s. Maria died in 1898, and Herman remarried to Florence G. Voight in 1903. With Florence, Herman had one son and four more daughters. Herman was born in Cincinnati in 1853 and was educated in the public schools. He graduated from Cincinnati Law School in 1874 and served in the Ohio General Assembly in 1876. He ran a practice with partner Bettinger until 1884, when he was elected judge of the probate bench. He served in the U.S. Congress from 1902 to 1911. Later, Herman founded the Glenway Loan and Deposit Company.

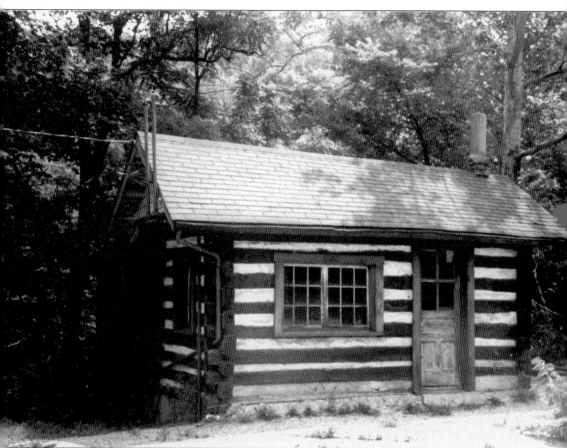

Bernard Hausfeld was born in 1838 and arrived in the United States in 1856. He settled in a log house on Cleves Warsaw Road near Muddy Creek Road around 1870 with his wife Mary, and four of their children, Edward, Henry, Lucy, and Louise. This log cabin was built on the property around 1928 by a man named Moffit, using trolley poles as building materials. Bernard's son Henry (1873–1951) married Mary L. Pontius (1887–1962), and they had nine children. This farm was home to cattle and horses, and the Hausfelds planted corn and vegetables on the steep slopes. The couple's first son, Elmer Hausfeld, helped construct Delhi's first sewer lines, spent 37 years driving a school bus, and 34 years as a trustee of Delhi. He passed away in 1985.

Next to the Hausfeld log house was this log barn, which was packed with farming equipment. Carriage equipment hung on the outside. An old anti-thievery sign, indicative of the signs old farmers used to discourage horse thieves, was also found in the barn. Elmer Hausfeld wrote that he and other farmers formed a union to discuss agriculture problems and solutions. The union members also purchased seed and feed together to get cheaper prices. They rotated through three different meeting places: one at Klawitter's across from Our Lady of Victory, one at Greenwell and Delhi Roads, and one at Ebenezer and Rapid Run Roads.

John Cleves Symmes had two daughters, one of whom was this woman, Anna. She met William Henry Harrison and quickly fell in love with him. When she told her father of her intentions to marry the army officer who would one day become president, he tried to persuade her against the marriage. He is quoted as saying, "he can neither bleed, plead, or preach."

This drawing shows William Henry Harrison, America's ninth president. By today's standards, he would have made a great real estate salesman. Sometime between 1790 and 1810, he partnered with Jacob Burnet and James Findlay to buy a large portion of land from Elias Boudinot. Many of Delhi's early pioneers bought their farmland from Harrison's portion.

Robert Wilke was born on May 18, 1914, to August J. and Rose Wubbeler. The family spent their early years at their home on Delhi Road, but later moved closer to Greenwell Road. Robert moved out west with a dream of becoming an actor in Hollywood. Although he had no training, he got his foot in the door as a stuntman in the 1930s, and by the 1940s started getting parts in western serials such as *Roy Rogers* and *Durango Kid*. He had a 50-year career playing outlaw bank robbers or neighborhood tough guys. Robert's characters always seemed to get killed on screen.

John Cleves Symmes seems to have had two lives. The first was as a congressman from New Jersey. Then, fur trader Benjamin Stites convinced John to buy a large portion of the Miami Valley in 1787. Today, that deal is called the Symmes or Miami Purchase. Symmes bought 300,000 acres at 67¢ per acre. In 1788, the first group of pioneers, led by Benjamin Stites, settled near the present-day Lunken Airport. The second group arrived at Yeatman's Cove on December 26, 1788, part of present-day Cincinnati. Symmes, however, passed both these settlements in February 1789 and settled in an area he called North Bend. Believing this area was too far from civilization, in May 1789 he instructed his brother, Timothy Symmes, to build a village seven miles up the river at South Bend in present-day Delhi. A flood in 1792 forced most of the South Bend settlers up into the hills where Mount St. Joseph now stands.